CONNECTICUT
BEER

CONNECTICUT BEER

A HISTORY OF
NUTMEG STATE BREWING

WILL SISS

Foreword by Ron Page, head brewer of City Steam Brewery Café

AMERICAN PALATE

Published by American Palate

A Division of The History Press

Charleston, SC 29403

www.historypress.net

Copyright © 2015 by Will Siss

All rights reserved

Front cover image, "Lighthouse Twilight," by Versageek,
www.flickr.com/photos/versageek, CC-BY-SA-3.0.

First published 2015

Manufactured in the United States

ISBN 978.1.62619.793.0

Library of Congress Control Number: 2015931726

CONTENTS

CONTENTS

FOREWORD

As a twenty-five-year frontline veteran of Connecticut's "Beer Wars," I realized upon reading the draft of Will Siss's new book that the old adage is true: you *can* learn something new every day! Just his first, well-researched chapter regarding the history of brewing in Connecticut is worth the price of admission. Not to mention the fond childhood memories Will's description of the state's last working post-prohibition brewery—Hull Brewing Company of New Haven—brought back to life. Reborn was the ghost of Alcide Page, my French Canadian grandfather, driving us kids past the old brick plant on Congress Avenue in his '56 Buick and whimsically stating that if he had his way, he would get a job there and spend all day lying with his head underneath an ever-flowing tap. If ever there was a subliminal introduction to the heavenly pleasure of malt, grain and hops…

Fast-forward to the 1980s. After Hull's closed, the passion for real local beer was kept smoldering ever so slightly by a small guerrilla band of homebrewers. Working solo or in isolated groups, these dedicated amateurs refused to let the fire die. And then the flame—fueled by the Average Joe's latent desire for a richer, more authentic flavor—burst suddenly and with great ferocity into the world. Or, to make a long story short: people opened microbreweries.

As Will points out, many of those first fledgling breweries have since closed. Commercial brewing is, after all, a difficult business first, a glorious passion second. Anyone who thinks differently must not understand the intricacies of label design, frozen glue, broken pumps, government

FOREWORD

forms, rising rent, raw material shortages, undulating consumer demand and overwhelming competition in the face of unrelenting corporate conglomeration! The list goes on, but that's not our problem. Our problem is deciding which of the myriad near mystical modern micro taps we should lay our own heads under. Will's book should help immensely in that regard. But don't put off sampling Connecticut's incredible ales for too long. You know what they also say—"Beer today, gone tomorrow!"

RON PAGE,
Head Brewer, City Steam Brewery Café,
December 6, 2014

ACKNOWLEDGEMENTS

Thanks to The History Press, and specifically my commissioning editor, Tabitha Dulla, who was helpful to me throughout the writing and editing phases of this book.

Also, many thanks to Rich Gray, my long-suffering editor at the *Waterbury* (CT) *Republican-American*, for which I write the "Beer Snob" column.

I drew plenty of inspiration from my fellow alco-journalists, especially from fellow History Press authors Josh Christie (*Maine Beer*) and Brian Aldrich and Michael Meredith (*New Hampshire Beer*). I should also thank my fellow beer writers whose work I admire, including Stephen Wood, Gregg Glaser, Carla Jean Lauter, Norman Miller, Astrid Cook and Aron Daniels.

Thanks to George and Dale Miller, who were kind enough to let me examine their well-tended bottle, can and coaster collections. Also, thanks to Colin M. Caplan, Charles L. Brooks and Jeff Browning for giving me insight into Connecticut's brewery history. My history section was also made better by fellow Gettysburgian Stephen Petrus.

Many thanks to photographers Stacey Blanchard, Roxanne McHatten and Paul DiPasquale for their eyes and shutters. Thanks also to the boys and girl of the Krausen Commandos of Northwest Connecticut, whose homebrewing creativity was of constant inspiration.

I'd like to thank all the brewers, bar owners, bartenders and keg washers for their hard work and love of craft.

Finally, I would like to thank my family and especially Madigan Siss, my loving and patient wife.

Author's Note

The information in *Connecticut Beer: A History of Nutmeg State Brewing* is, to the best of my knowledge, accurate and current. As you'll find in this book, breweries are constantly evolving. Breweries open and close regularly, so I encourage you to reach out to the breweries or check their websites before visiting if you have any questions.

I also recommend checking in with CT Beer Trail, a website manned by Bryon Turner, who is as up on all things Connecticut beer as anyone. Go to www.ctbeertrail.net for more information.

INTRODUCTION

Some communities draw you in whether you realize it or not. For me, that's how it was with the Connecticut beer community—before I knew it, I was entranced and had even assigned myself a role.

In 2005, I was a newspaper reporter covering local crimes, the political beat and educational issues in the Naugatuck Valley for the *Waterbury* (CT) *Republican-American*. I enjoyed the privilege of writing for a living while talking to strangers, but I knew my heart wasn't in it. Maybe it was because I was from New Jersey and not as invested in the local goings-on as I would have been if I were a native. It was around this time that I got the idea of creating my own column—something that would allow me to write, but maybe about a topic that intrigued me more than hit-and-runs and scandal.

I'd recently hosted a party to which my buddy John Labeck brought a whole bunch of different beers. "Try this," he said. "It's called Dead Guy Ale. It's from Oregon." Beer had been a part of my life since I was young, being from a German-American family that enjoyed its Budweiser. In college, I'd enjoyed a Yuengling or two. Soon after, I'd been fairly loyal to Stella Artois. But this beer, and several others that John had brought along, were really opening me up to something new. Being someone who can't enjoy a song without reading all about the band, I had to read all about this craft beer thing. It was in reading Garrett Oliver's amazing book *The Brewmaster's Table* that I saw the light and decided what I wanted to do: write for a living while drinking with strangers.

The first Connecticut brewery I profiled for my new column—which I called "Beer Snob" at an attempt at irony—was New England Brewing

Company. This tiny space in nearby Woodbridge was housed in a former mechanic's garage. It made Sea Hag IPA and Imperial Stout Trooper, two ends of the taste spectrum for which I had almost equal affinity (I'm still more of a malt head than a hop head, however). This column and dozens after it showed me that the "craft beer scene" in Connecticut was not about how many different styles you could try. It was about the people behind the beer.

What I tried to do with this book is introduce you to the community of Connecticut beer, beginning with its roots. While I'd visited nearly all the breweries in the state, I did not have much knowledge of the state's brewing history. Colonial settlers in Connecticut drank beer for the same reason most people from that time drank it: it kept them alive. New Haven turned into the brewing capital of the state. When immigrants brought their traditions for making beer in the mid-nineteenth century, Connecticut's brewery world was thriving, with drinkers retaining a loyalty to English ales as well as an interest in the German lagers.

As I came to learn, Prohibition did not stop Connecticut beer drinkers from enjoying their drink of choice, but it nearly killed the brewery industry in the state. Only Hull Brewing of New Haven survived the thirteen-year legal booze drought. Beginning in the 1970s, however, homebrewers would revive the desire for diverse tastes. Some of those homebrewers would go on to make beer professionally and start a new wave of Connecticut breweries.

I hope you enjoy reading about the people behind Connecticut beer and consider yourselves members of our growing community. There are no restrictions on membership, just a willingness to support the hardworking men and women who create beer in the Nutmeg State.

Connecticut Beer

A Brief History

Ever since it was a British colony, Connecticut has loved beer. However, its Puritan roots, waves of temperance and prohibitions, as well as a period of decline in local breweries, show that the Nutmeg State and alcohol have weathered a complex relationship. In the earliest days, colonists carried over their attraction to ales, which served as refreshments but also as healthy substitutes for contaminated drinking water. Importing English ingredients was an option, but colonists turned to corn, oats and pumpkin when barley was unavailable and sometimes used spruce in place of hops. "Over the centuries, it has continued to be made despite shortages of ingredients, competition from other products, fervent social opposition, legal restrictions, and recently, changing public attitudes toward alcohol use," wrote Richard C. Malley and Michelle E. Parish in their Connecticut Historical Society Bulletin article, "Beer and the Brewing of Beer in Connecticut."

Early brewers sometimes played important roles in their cities and beyond. Until the mid-nineteenth century, most beer was made at home. One colonist who would later know fame as a leader in the Revolutionary War was one of the state's early brewers. Israel Putnam ran a tavern called The General Wolfe in what was then known as the Brooklyn Parish of Pomfret. The location was "ideal for a tavern," according to author John Niven, as it was on the main road from Norwich to Hartford that would then lead on to Boston. "Taverners occupied a unique position in the New England of the eighteenth century," Niven wrote in *Connecticut Hero, Israel Putnam*. "The Tavern itself was a center for the exchange of news, frequently used as the

meeting place for town government and the headquarters for the local militia. Many of the local land and business transactions took place in the taproom or the private parlors, of which there were two in The General Wolfe. The innkeeper himself usually commanded high status in the community. And, if he happened to be the celebrated Colonel Putnam, his counsel must have been solicited many times in business or in political and militia affairs. He would be the first person in the community to receive news from outside."

As they did throughout New England, taverns played important roles historically in Connecticut. The Griswold Inn in Essex dates back to 1776, when it began its uninterrupted reign as a watering hole for shipbuilders, sailors and just about anyone else who might come upon its taproom. Temperance movement protesters targeted the inn during the 1840s, but the beer and spirits continued to flow, even during Prohibition. It stands as one of the oldest continuously operating taverns in the country. Even George Washington drank there, as he did at Fuller's Tavern (built in 1789), which still stands in Berlin.

In the 1800s, Connecticut saw the rise of breweries with the advent of refrigeration and pasteurization. These breweries were mainly in the cities: New Haven, Hartford, Bridgeport and Waterbury. German immigrants began operating Connecticut breweries during the second half of the nineteenth century. "Along with the German immigrants came a basic change in brewing technique and tastes," wrote Malley and Parish. "The clear lager beer favored by most Germans soon displaced the darker English style ales in popularity."

NEW HAVEN'S CONTRIBUTION

Of all the Connecticut cities, New Haven has the richest beer history in the state. Colonial records dating to the 1630s show that Stephen Goodyear, a deputy governor, was given sole "liberty" to brew in the city and that "[a]ll other excluded without the lik liberty & consent of the towne."

One of the most important sites in all of Connecticut drinking history begins where Goodyear brewed his beer at the corner of Chapel and College Streets. It was on this site—right off the New Haven Green, near what would become the Yale campus—that in 1659 there was erected the town's first "ordinary," or town-sanctioned tavern that sold liquor and offered room and board. Convenient to sailors and shipbuilders, as architectural historian

Colin M. Caplan wrote in a study of the site, the ordinary was later fittingly called Beers Tavern, named for innkeeper Isaac Beers. Benedict Arnold made a dramatic visit to the tavern on April 20, 1775, when as captain of the Governor's Foot Guard he demanded that the politicians there give him the keys to the "powder house," where he would get ammunition to fight the British. In June of that year, George Washington stayed overnight at the Beers Tavern.

Augustus Russell Street bought the tavern in 1840, and eight years later, he replaced the building with a hotel. The New Haven Hotel was the largest of its kind in the growing city when it was completed in 1850, with room enough for two hundred people. After Street's death, the hotel was renamed Moseley's New Haven House for its new owner, Seth H. Moseley. Owners tore that hotel down in 1910 and replaced it with Hotel Taft, named for President William Howard Taft.

It's this 1911 building, designed by New York architect F.M. Andrews, that remains today. After serving as the center for all things social for decades, Prohibition brought the end of the bar, at least officially. "The Speakeasy was born at this time and it is believed that one of these secret clubs existed in the Grill Room in the basement," according to Caplan. The bar became known as the Tap Room after Prohibition lifted in 1933, and Hotel Taft continued for another forty years. The Tap Room sat vacant until 1982, when it was reborn as Richter's, an early proponent of craft beer. That bar lasted until 2011; however, two years later, several partners refurbished the old gem, and it's now a stunning, dark wood masterpiece of a bar called Ordinary.

In terms of breweries, New Haven boasted eight by 1885, one of which was Quinnipiac Brewing Company. A New Haven laborer named Peter Schleippmann and New York City brewer William Spittler bought the property in 1881 and made lager in the Fairhaven section of the city. The partners fell into debt and declared bankruptcy in 1885. In came Nathaniel W. Kendall, who bought the brewery for $5,000 and turned it around. It was soon powered by a two-hundred-horsepower steam engine and included two twenty-five-ton refrigerating machines. Using some German immigrant labor, by 1892 it had increased its production to fifty thousand barrels of beer per year (a barrel is thirty-one U.S. gallons). In 1902, Kendall reorganized the company as the Yale Brewing Company.

Yale Brewing was not destined to last, and its fate was echoed by many other commercial breweries. Kendall sold the company in 1919, the year that the Volstead Act passed. The Volstead Act was also known as the National Prohibition Act, and it carried out the Eighteenth Amendment

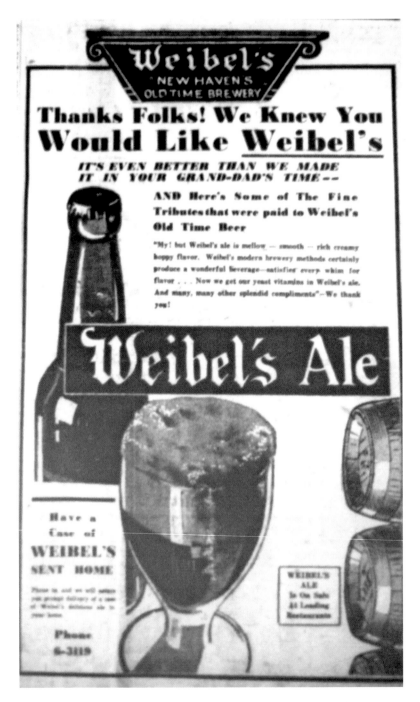

A newspaper advertisement for Weibel Brewing Company. *Courtesy of George and Dale Miller.*

of the U.S. Constitution, effectively making alcoholic beverages and their consumption illegal. Christian Feigenspan, who owned brewing companies in Newark, New Jersey, and Albany, New York, purchased Yale Brewing that year, hoping that making "cereal beverages"—beer made at 2.75 percent alcohol by volume—would keep the company viable. It didn't. The plant basically shut down in 1922 but was reopened and modernized when Prohibition ended. After a ten-year run as the newly reincorporated New Haven Brewing Company, it closed its doors for good.

There were several other important nineteenth-century New Haven breweries, with approximately thirty in the city just before Prohibition. One was founded by Philip Fresenius, a German immigrant who made "standard and extra pale lagers." From 1852, he ran Fresenius Brewing; after his death in 1888, it continued as Philip Fresenius' Sons Brewing until Prohibition. Weibel Brewing Company, which started its operations in 1859 and made ales and lagers, was also bruised by Prohibition, staying viable through its ability to make soda, other carbonated drinks and low-alcohol "near beer." (One late 1920s advertisement for Weibel's near beer read, "Here's to your good health, your family's good health and may you live long and prosper.") The brewery closed its doors in 1936.

Other Pre-Prohibition Breweries

Breweries thrived in other Connecticut cities in the nineteenth century. In 1889, Martin Hellmann bought out a brewery he owned with Michael Kip and relocated it to Bank Street in Waterbury, naming it the Martin Hellmann Naugatuck Valley Brewery. His wife renamed it Hellmann Brewing Company after her husband's death in 1892, and it wasn't until 1927 that it changed hands again, being purchased by George H. Largay. After trying his hand making beer in breweries around the Northeast, Largay made two brewery purchases: Hellman Brewing and another in Amsterdam, New York. When the Amsterdam Brewing Company went out of business, he focused on his Waterbury prospect, which paid off. The renamed Largay Brewery shared Waterbury with the Eagle Brewery. Largay lasted through World War II before closing in 1947.

In New Britain, Cremo Brewing Company bought a brewery that was selling "health beer" in 1905, and the owners built it into a much more successful business. Cremo's beer was profitable until Prohibition, and

when it reopened upon repeal, brewmaster Oscar Brockert hosted a grand opening, when an estimated five thousand people visited the brewery, according to author and beer can collector Jules Kish. Cremo distributed its products under the labels Diplomat, Cremo and Manhattan, producing as much as seventy-five thousand barrels per year at its peak. It closed after a fifty-year run.

There were several other city-based, pre-Prohibition breweries. After German-born brewer George F. Eckart died in 1889, he passed his Bridgeport brewery along to his sons, Frederick and George, who had trained to become master brewers in New York City. Eckart Brothers Brewing Company produced lagers and porters, and the owners also ran a bottling works building next to their brewery on North Avenue. The brewery lasted until—you guessed it—Prohibition.

Other breweries tended to thrive best in or near cities. For example, in Derby, Old England Brewing Company started life as Derby and Ansonia Brewing Company in 1897 and was reissued a permit after the repeal of Prohibition; it lasted until 1941. In Hartford, the New England Brewing Company (not to be confused with the one in Woodbridge today) lasted from 1897 to 1922.

PROHIBITION IN CONNECTICUT

Countering Connecticut's loyal beer drinkers were some of the country's earliest and most vocal temperance supporters, who called for less alcohol drinking, and prohibitionists, who called for making drinking all alcohol illegal. Some have said that the movement that would end up convincing Congress to pass the Eighteenth Amendment had its roots in Connecticut—the small northwest town of Litchfield to be specific. It was there that Lyman Beecher served as a Presbyterian minister at the Congregational Church from 1810 to 1826. "Intemperance is the sin of our land, and, with our boundless prosperity, is coming in upon us like a flood," Beecher wrote, "and if anything shall defeat the hopes of the world, which hang upon our experiment of civil liberty, it is that river of fire, which is rolling through the land, destroying the vital air, and extending around an atmosphere of death."

Following the lead of Maine, Connecticut experimented with its own statewide ban in 1854. This did not prove to be very successful, partially because it was not enforced. In 1872, pro-temperance citizens fought for

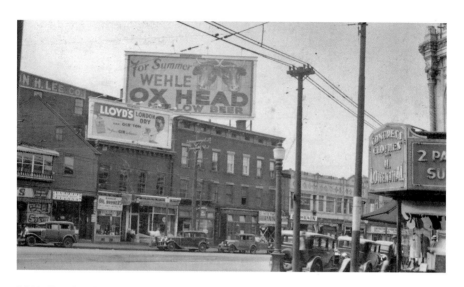

Wehle Brewing Company advertisement, New Haven, circa 1935. *Courtesy of Colin M. Caplan; photo taken by United Advertising Corporation.*

a "local option law," which gave each town a chance to vote annually whether they wanted to allow the sale of alcohol within city limits. In his master's thesis, "Connecticut Goes Dry," Charles L. Brooks noted that in 1872, 58 percent of the 1,668 retail liquor licenses granted in the state were concentrated in New Haven, Hartford, Bridgeport, Waterbury and Meriden. "The remaining 695 licenses were spread among 79 towns," he wrote. "The vast majority of these towns were centers of manufacturing, and not surprisingly comprised a large immigrant population." (The tiny town of Bridgewater was the last one in Connecticut to remain "dry," until 2014, when it voted to allow alcohol sales.)

Temperance organizations, including the Anti-Saloon League, slowly made strides over the decades following the American Civil War, using the pulpit and politicians to spread its message that making alcohol illegal would right many of the wrongs that plagued American families. Connecticut officially resisted national Prohibition; in February 1919, state senators voted twenty to fourteen against it, joining only Rhode Island. However, just a few months later, when the U.S. Congress passed the Eighteenth Amendment, Connecticut legally had to comply. Thirsty residents found creative, illegal ways to enjoy their beer in and out of their homes.

By the end of Prohibition, Connecticut residents were eager for a lifting of the ban on alcohol. A referendum in 1932 showed that 85.9 percent of

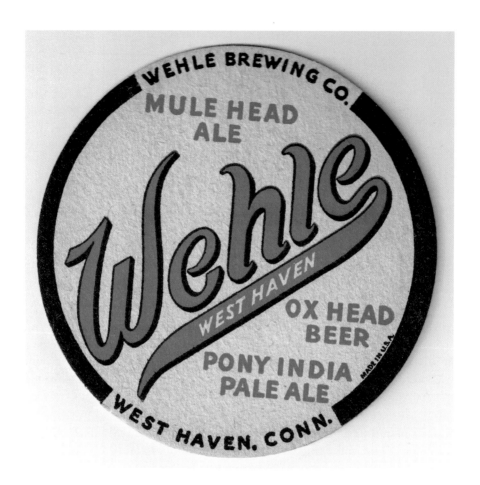

Wehle Brewing Company coaster. *Courtesy of George and Dale Miller.*

Connecticut had voted in favor of repeal, the highest percentage of any state, according to Brooks. A vote of nine to zero at the Connecticut Convention to ratify the Twenty-first Amendment followed. "Connecticut's breweries wasted no time in preparing for the repeal of prohibition," Brooks wrote. At a meeting of the Connecticut Brewers Association, eleven breweries announced that they had between 2.3 million and 3.1 million gallons of beer ready for sale.

Connecticut Post-Prohibition

For many reasons, the state was ready for the Prohibition repeal. For example, crime statistics compiled by the *Bridgeport Post* showed the high number of arrests for the city's fiscal years beginning with 1920. "That liquor was plentifully manufactured and eagerly drunk to such an extent that hundreds each year faced City court for excesses in its use and resulting transgressions against peace and order is indicated by the records," the paper noted. City police never arrested fewer than 353 people per year for intoxication during that time period, with a record number of 906 for the fiscal year ending with March 1930.

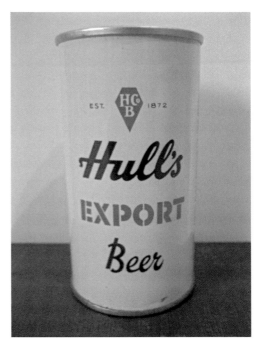

An original Hull's Export Beer, from George and Dale Miller's collection. *Photo by the author.*

Breweries in Connecticut generally suffered during Prohibition. Wehle Brewing Company in West Haven was a rare brewery to start up from scratch soon after 1933. Thirsty patrons welcomed the brewery. "We feel that besides furthering our own interests, we are bestowing a civic benefit by taking the brewing business out of the corrupt hands into which it fell with the advent of Prohibition," co-owner Raymond J. Wehle said in a *New Haven Register* article. The brewery thrived, changed hands and eventually was sold in 1942 to a New York brewing firm before closing.

The only pre-Prohibition Connecticut brewery that had any lasting post-Prohibition impact was the Hull Brewing Company of New Haven, which was started in 1872 by Colonel William H. Hull on Whiting Street. In 1920, it made non-alcoholic malt beverages to get by. After repeal, Hull's took over the former Fresenius' Sons facility on Congress Avenue, where Hull's erected a statue of Gambrinus, the bearded, mythical king of Flanders who is said to have invented beer. Hull's used its own wells

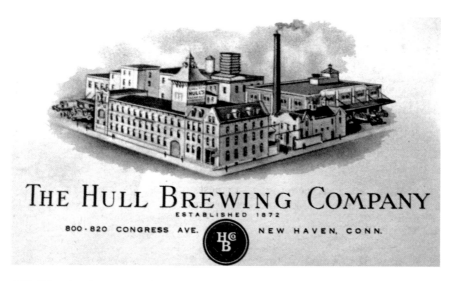

A Hull Brewing Company business card. *Courtesy of George and Dale Miller.*

Hull Brewing Company advertisement, New Haven, circa 1950. *Courtesy of Colin M. Caplan; photo taken by United Advertising Corporation.*

"Having a Beer in Art's Sportsman's Tavern on a rainy day in Colchester, Connecticut," November 1940. *Courtesy of the Library of Congress, LC-USF347-042297-D. Photo by Jack Delano.*

to benefit from the water that flowed beneath the streets of the city. It made Hull's Export, Cream Ale, Lager Beer and Dingle Bay Brand Cream Ale and was one of the first to produce "light" beer. It was light in color and flavor, but Hull's Light Beer in 1940 was not billed as a low-calorie option. The government sent Hull's Light to U.S. military forces during World War II. After the war, Hull's slowly found itself one of the only independent breweries in the region, standing in the overwhelming shadow of behemoths like Anheuser-Busch and Joseph Schlitz Brewing Company.

By the 1950s, most American commercial beer was produced by a few large corporations. "It was a deliberate deconstruction of the brewing world by the major breweries," said Jeff Browning, the head brewer of BruRm @ BAR in New Haven and an amateur Connecticut beer historian. "Local breweries couldn't make beer cheaply enough, and then advertising became such a big factor at that point. Hull's was the biggest player in Connecticut up through the '60s. Connecticut was the last bastions of ales; then Bud

targeted Hull's. Anheuser-Busch came to bars and said, 'If you take Hull's off, we'll give you no-interest loans.'" Hull's held out until 1977, and only after it had ceased making beer altogether and created the soft drink Malta Caribe did it finally close its doors, ending an era.

The Rise of Connecticut's Mircrobreweries

It took more than a decade before breweries took hold in Connecticut, where they would move from the cities to the suburbs. During that period, homebrewers honed their skills, including members of the Underground Brewers of Connecticut, which started three years before President Jimmy Carter signed a law in 1978 that legalized homebrewing. It was thanks in large part to these homebrewers that the next generation of Connecticut brewing would emerge.

Not surprisingly, it was New Haven that served as the launching pad for this new wave. In 1989, a group of partners opened Elm City Brewing Company on Grand Avenue. In honor of Hull's Export Ale, the partners decided to also can the beers. While Elm City Brewing went out of businesses in 1998, it provided a proving ground for three head brewers who still work professionally: Jeff Browning (BruRm @ BAR), Ron Page (City Steam Brewery Café) and Rob Leonard (New England Brewing).

To help Connecticut compete, a state law was passed in 1984 that forbade charging state wholesalers more than their lowest price in Massachusetts, New York and Rhode Island. "The law could be a bonanza for Connecticut beer and wine drinkers, who, especially in the case of beer, often have paid more than their peers in states bordering Connecticut," a reporter explained in a *New Haven Register* article from the time.

By the early 1990s, the microbrewery "craze" was starting to spread nationally. The movement led to the popularity of brewpubs, although not all were well managed. Hartford Brewery Limited tried to thrive in Hartford but only lasted a few years (its recipes live on in Hartford Better Beer Company, which makes its beer in Maine). Chains like John Harvard's and Hops popped up in the state but eventually folded in Connecticut. In *The Good Beer Guide to New England*, Andy Crouch put it this way: "If the 1980s were the pioneer years, the 1990s were the years of unrealistic enthusiasm. The level of exuberance was matched only by that of the dot-com age. By 1995, there were 500 breweries operating in the United States,

with an average of 3 to 4 new breweries opening every week. By 1996, that number had more than doubled, to 1,102 breweries, and 300 more opened that year…By 1998, openings and closing nearly equaled one another as a major correction in the industry plunged growth from a high of a 51 percent increase in production volume in 1995 to flat growth in 1998."

Connecticut drinkers saw their share of "here today, gone tomorrow" microbreweries in the 1990s. Colorado Brewing & Trading Company was a brewpub that started in Danbury and lasted until 2004, while Hammer & Nail Brewing in Watertown also had a healthy run and plenty of accolades but eventually closed.

In the 2000s, the number of Connecticut breweries slowly started to rise, mirroring the national trend. Fueled in part by an overall growing interest in craft beer and more solidified business models, breweries started popping up around the state, particularly on the Interstate 91 and 95 corridors. Thanks to the efforts of Cambridge House Brewpub's former owners, a law was changed in 2007 to allow brewpubs to package and sell their own beer. By 2011, there were fifteen craft breweries in the state, and a year later, breweries could obtain licenses that allowed them to sell pints and half-gallon "growlers" directly from their taps. Seven breweries opened up in the state in 2012, followed by more than a dozen since then.

Time will tell whether the state is hitting its stride in its attempt to catch up to more established New England beer states like Vermont and Massachusetts. Nevertheless, it's a vibrant time for beer drinkers watching Connecticut's brewery industry grow into its next stage of life.

NEW ENGLAND BREWING COMPANY

175 Amity Road, Woodbridge
(203) 387-2222
www.newenglandbrewing.com
Founded in 1989 (changed ownership in 2002)

THE BREWERY

Reinvention has been kind to New England Brewing Company (NEBCO). What started as a brewpub that nearly faded out of existence was revived when its head brewer decided to take the name and a few recipes and strike out on his own at a smaller brewery miles away. When the bills nearly got too high to manage, a new brewer with a penchant for India pale ales helped make NEBCO one of the state's most buzzed-about breweries.

In a way, NEBCO was a resurrection from the beginning. The name was used by a now defunct brewery as early as 1897 in Hartford. The 1989 version in Norwalk was owned by Dick and Marsha King and served as a brewpub in the southeastern part of the state. It was doing well into the 1990s, but the owners decided that they would be leaving the brewing world. They sold the brands to their head brewer, Rob Leonard, who with partner Pete Seaman turned a former mechanic's garage in Woodbridge into a small brewery in August 2002. Leonard had already been brewing for about ten

New England Brewing Company's logo. *Photo by the author.*

years; before NEBCO, he was a homebrewer and then worked for Elm City Brewing, the John Harvard's chain of breweries and a consulting firm helping breweries.

At first, the brewery played it safe, offering its inoffensive Atlantic Amber Ale as its first beer. However, NEBCO made a bold move by canning. "People thought we were crazy, but it doubled sales overnight and kept the doors open," Leonard said. Those doors stayed open for Friday night parties, which would sometimes devolve into drunken singalongs, but that was okay. There were early fan favorites, especially the Imperial Stout Trooper, a Russian imperial stout that made some headlines when George Lucas of *Star Wars* fame sent NEBCO a cease-and-desist order (it has since covered up the iconic Storm Trooper mask

with glasses, a nose and a mustache). By 2008, however, the company was "swimming in debt," Leonard explained. It needed something that would lift it up. It turned out to be Matt Westfall.

Like many other Connecticut brewers, Westfall started his journey at Zok's Homebrew and Winemaking Supplies in Willimantic, near Eastern

New England Brewing Company brewers Sebastian D'Agostino and Matt Weichner. *Photo by the author.*

Connecticut State University, where he was studying sociology. After graduation, Westfall increased his homebrewing to up to four times a week. Failing to make it into graduate school, Westfall moved to Portland, Oregon, where he worked for a beer distributor. It wasn't long before he had returned to school, this time for brewing, at the American Brewers Guild in Vermont. This led to stints working at breweries in California, but when it came time for doing his internship, Westfall wanted to be closer to his hometown and chose NEBCO. "When I came in, it was whatever needed to be done; I cleaned, canned, did brewing," Westfall said. "I got to do more at this company than anywhere else."

Within that first year, Westfall was brewing his own recipes for NEBCO, starting with the Alpha Weizen, a dry-hopped hefeweizen. His big breakthrough, and the beer that still gets beer geeks excited and lined up for growler-fills, is Gandhi-Bot, a double India pale ale. It bursts with peach and mango and boldly parades around your tongue in waves of gentle bitterness and piney acidity. This led to a series of other beers that let individual hop varieties shine: the double IPAs Fuzzy Baby Ducks (Citra hop) and Coriolis (Nelson Sauvin) and the pale ales Supernaut (Mosaic) and Galaxy (named for its hop). Westfall's influence broadened when he convinced Leonard to open the doors to let people bring their growlers for filling. The first few weekends were spent mostly sitting at the brewery more or less alone, waiting for anyone to stop by. Over time, and with a spreading reputation, a line would form. Now you need to get to the brewery well before its 11:00 a.m. Saturday opening if you want a spot. "I remember there was one day, I was writing down on the board what we'd be serving, and there's a bunch of people outside the window with their phones, letting everybody know what it was," Westfall said.

In December 2013, Leonard expanded into a fifteen-barrel system across the street in a larger building, just shy of ten thousand square feet. This allowed NEBCO to meet the increased demand for its beer, especially Sea Hag IPA, its most prominent one on tap. It also has room for a ten-barrel tank, where it brews small batches available on-premises only, known as the "Fat-10-er" series. Westfall said that he's happy to get a reputation of someone who can make fine IPAs, but he wants to stretch out in other directions, including lagering.

In analyzing the current boom in Connecticut breweries, Leonard cannot help but remember the "shakedown" of the 1990s, when so many microbreweries came and went due to a variety of reasons. "There will be another shakedown," he said. "People will go back to the [breweries] that

are good. Too many people are getting into it. I don't know if that can last…
You see the starry eyes and how they buy the equipment and hats before
making beer. My hope is that they make really good beer."

THE BEER

If you were to set up a long table of NEBCO beers to sample, you'd best off
start with ELM CITY LAGER, which is pretty much as light as it gets for the
brewery. That doesn't mean it's tasteless; in fact, it stays true to the pilsner
style and comes across as gently bitter and crisp. In terms of its year-round
beer, it only gets bolder and hoppier from there. The popular SEA HAG IPA
features a mix of hops and embodies what brewer Matt Westfall calls the East
Coast IPA style, which emphasizes balance over bitterness. Even bolder is
668: THE NEIGHBOR OF THE BEAST, an intense (9 percent ABV) Belgian-style
strong pale ale that's soupy in mouthfeel and rings loudly with a bitterness
that borders on the funky, thanks to the yeast. Going in another decidedly
funky direction is WEISS TRASH CULTURE, a Berlinerweiss that shows off an
ability to surf the dangerous waters of sour as they crash up against the tide
of low alcohol.

Stopping by for a growler-fill often means waiting, but with some
nice folks. The longest lines are for those coveting IPAs. Whether
it's the zippy GALAXY, the exotic CORIOLIS or the citrusy FUZZY BABY
DUCKS and SUPERNAUT, you're in for a wild ride. Hop heads will
appreciate the stories these beers tell, as they morph from first sip to
finish, mellowing gently. For me, the beer formerly known as GANDHI-
BOT IPA is still the most enjoyable, but that could be my preference
for the blend of three American hops. Luckily, this is also available in
four-pack cans, albeit rarely.

NEBCO's seasonally available beers are also worth a try. As a malt head
and *Star Wars* geek, I've always had an affinity for winter's IMPERIAL STOUT
TROOPER. In the fall, there's the coffee robustness of GHOST PIGEON PORTER,
and the summer brings SCRUMTRULESCENT SAISON, a wonderful ale that's
peppery, a little funky and refreshing.

Q&A

How would you describe your customers?

"They're insatiable. They say, 'When's that coming out?' I'm not like that. I like what I like and I buy that. I love that they are passionate about that. Matt [Westfall, brewer] is awesome at knowing what we need to throw out there. People really like what we're doing here. That we care about it. Now it's, 'What are you going to do next?'….And they are so much more knowledgeable now than in the early '90s. Now I get nervous that I'll get stumped in the liquor store. They know everything."

–Rob Leonard, president, New England Brewing Company

BruRm @ BAR

254 Crown Street, New Haven
(203) 495-8924
www.barnightclub.com
Founded in 1996

THE BREWERY

If it's a Saturday night and school is in session, stepping into BruRm @ BAR means entering a multi-layered assault on the senses. You can make a left and go into the BruRm, which is a boxy, industrial barroom with a lighted pool table and plenty of bustle. This section is part of the building that goes back to the 1880s and used to be a dance hall in the 1940s. Beyond that, if you follow the thumping music, you reach the nightclub section, which also has a bar. Backing up slowly, wary of stumbling Yale coeds, you end up at the entrance again, but keep going and it's the mellow dining area where you'll smell the New Haven–style brick oven pizza being made. This is also where you'll find the ten-barrel brewhouse; just a few vessels on a platform is what counts as Jeff Browning's laboratory. The veteran brewer with a passion for Connecticut beer history sports a mop of curly, tawny hair. He's here many mornings, brewing the beer that helps lubricate the nightlife. "This bar is unique in that you have everything from a twenty-one-year-old shiny-skirted college girl here and there's your seventy-year-old professor,"

Browning said during one of his morning brew sessions. "We have the ability to make everyone comfortable somehow."

BruRm opened in February 1996 as an addition to BAR, the nightclub/pizza joint that had opened five years earlier. BAR was part of the vanguard of clubs that now litter Crown Street and the surrounding blocks. It has three bars, one in each of its segments, with eighteen taps altogether; five to six of those beers tend to be from BruRm. "Since day one, we've always sold our beers and other beers, even when it was the kiss of death to sell others' beer," Browning said. "The idea is that you choose other quality beer that doesn't directly compete with yours. We've found that it's increased the demand for our beer."

One of BruRm's early assistant brewers was Jeff Shannon, who was studying full time at Yale at the time. A California native who moved to Connecticut in 1992, Shannon had recently shifted from studying neuroscience to yeast biology, making his interest in beer both personal and professional. "I started going to BAR because of the drink specials," said Shannon, who did earn his doctorate and now works in public education. "I got to be friendly with one of the bartenders, who knew I brewed beer, and she said that the owner

BruRm @ BAR owner and head brewer Jeff Browning. *Photo by the author.*

was thinking of turning the bar into a brewery." After putting some input into some styles, Shannon worked with the brewery's consultant and head brewer and said that he did his best to educate the customers about beer. Over time—which included working some shifts that started at 2:00 a.m.—Shannon had enough of the professional brewing life.

For Browning, the trek to become BruRm's head brewer has its roots in the 1970s in Milford, a beach community. As a teenager, Browning was already collecting beer paraphernalia, like old cans of Hull's, a New Haven brewery that would close in 1977. Early brewing attempts began with a kit he bought at a Caldor department store, and fermenting beer in his closet became a full-fledged passion. He was inspired by Taddy Porter, a rich English ale, and found guidance in Charlie Papazian's *The Complete Joy of Homebrewing* while brewing in the 1980s. By the early 1990s, Browning was making six batches a month and invited friends over to drink his beer and play darts. "I learned early on that everybody is a liar: people say they love your beer when they don't or say they don't like it at all, then have four in an hour. Consumption is the key to all commercial trade." This understanding of the market and gauging what's popular would play a role later on his career.

Before BruRm, Browning worked as a brewer at several other breweries, including Spring Street Brewing in New York City, Long Shore Brewing on Long Island and Diglio's, a short-lived brewpub in Hamden, Connecticut. After some time working for beer distributors, Browning made the decision in 1999 to try his hand at the New Haven brewery, which had already gone through two head brewers. His opening impressions of BruRm were not positive. "I came in and they sat me in the corner, and I ordered the Damn Good Stout," Browning recalled. "I was told—literally—that you don't want our beers. They had three beers on tap, and they were all infected."

Browning said he made some common sense adjustments, including putting tanks high enough so that gravity could help feed the beer through the lines and cut down on foam in the beer. Browning believes that his beers stand out because of the complexity of their ingredients. "I don't brew beers that are simple," he said. "I brew beers that get their depth of character using traditional forms of mashing instead of highly sweet malts and specialty malts...Beer should evoke an opinion. The idea of making well-made, middle-of-the-road beers is not something I care about...I brew beer that allows you not to go home with ugly chicks—or ugly men, whatever you're into."

When he's not promoting his own beer, he's promoting social causes through about forty fundraisers a year. For example, BruRm raises money for New Haven Reads (a local study area and library), as well as for a homeless

veterans group and an organization that helps those with pediatric AIDS. Part of that fundraising comes from Browning's annual Real Ale Festival in January. "Real ale" is a British term that means the beer comes from casks and is not artificially carbonated. The festival started with fifteen breweries, seven of which were foreign; in 2015, forty-four breweries participated, and almost all of them were from New England.

The Beer

The BruRm makes batches of four core beers. My favorite is the Damn Good Stout; it's got a creamy mouthfeel and a faint burnt-coffee bitterness that makes it as satisfying as an after-dinner espresso without causing the jitters. The AmBAR Ale has a fine caramel backbone to it but is refreshing and goes best with pizza (including the bar's famous mashed potato and garlic pie). The Pale Ale brings the most hop-bitterness to the glass, which is another plus for those who are into matching the spiciness of one of BAR's thin-crust pies. There's also the Toasted Blonde, which is the most balanced of the group, made with four different malts, but also has a citrus zing to it.

Depending on the time of year, there could be any of twelve to fifteen specialty ales on tap. Two that have gained plenty of fans are Girl Scout cookie–related: the Thin Mint Stout and the Peanut Butter Stout.

Q&A

What can today's brewers in Connecticut learn from the Connecticut brewers of the past?

"I think today's brewers can learn from the past brewers by paying attention to the current markets. Also, by being true to what they do best and not worry about what everybody else is brewing. Beer is not going anywhere. Remember: fads are fads, so brew what you are passionate about and prove to everyone else it's worth having around. Let the big breweries sell mass market–appeal beer. Every wave must hit the shore, and when this wave ends, it will be the talented, well-financed breweries that will be around for the next ten or fifteen years."

–Jeff Browning, head brewer, BruRm @ BAR

COTTRELL BREWING COMPANY

100 Mechanic Street #22, Pawcatuck
(860) 599-8213
www.cottrellbrewing.com
Founded in 1997

THE BREWERY

Way out on the eastern fringes of Connecticut, where it kisses the Rhode Island border, Cottrell Brewing has been quietly making quality beer. For twelve years, it made just one: Old Yankee Ale—an easy-drinking amber ale. It has since branched out into an IPA, a Scotch ale and, most recently, a pilsner. Cottrell is a rare example in Connecticut of a brewery that's stayed consistent in its offerings and represents the "old guard" of brewing in the state, even if that only stretches back to the Clinton administration.

The brewery itself is a piece of history, part of a hulking factory nestled between the Pawcatuck River and some beautiful neighborhoods. The 350,000-square-foot building was where Calvert Byron Cottrell—a relative of Nicholas Cottrell, who purchased land from Narragansett Indians in the mid-1700s—ran a printing press manufacturing plant and developed some innovative processes.

Decades later, Charles Cottrell Buffum Jr. was working as a management consultant in Boston. In his spare time, he homebrewed, and after a stint in

Cottrell Brewing Company sales representative Keith Drakos mans the taps at the brewery. *Photo by the author.*

London as a student and consultant, he continued to make his own beer. When he returned to the States, Buffum volunteered at the former Ipswich Brewing Company in Massachusetts. "I'd hang out with the brewer and start at 5:00 a.m.," Buffum said. "At that point, I just wanted to look at it from a larger scale, as a commercial operation, and see if it was something I wanted to do as a career. I had a lot of fun doing it, and I thought that it was time to chuck in the corporate towel."

In what he claimed was an "epiphany and moment of insanity," Buffum decided to return to his familial roots and lease ten thousand square feet in the same building where his great-great-grandfather (on his mother's side) made those printing presses. The year was 1997, when "craft beer" was becoming hip on a national scale. Unlike some during this era, Buffum was not in it to capitalize on a trend, but he did recognize that southern New England still had very few breweries. He decided to name his brewery after his family name, although the relatives who once worked in his building allegedly never touched a drop of alcohol.

His first beer was based on a recipe that an assistant at Ipswich was toying with; it became Old Yankee Ale, which at the time was a bit bitter for most

casual drinkers. "My philosophy was to do one thing and do it well, just like Heineken and Bass," Buffum said. While focusing on one beer for Cottrell, Buffum used the extra space to let "gypsy brewers" have a crack at making their own beer. He started with Trinity Brewhouse, from nearby Providence, Rhode Island, and later expanded. Cottrell has since added to his own portfolio of beers, starting with Mystic Bridge IPA, while also increasing his lineup of contracted beers. It's now the location where beer gets created for Safe Harbor Brewing of New London, GW Beer of Greenwich and even Trader Joe's (which distributes State Line IPA in Connecticut). Besides Trinity, Cottrell's out-of-state clients have included The Bronx Brewery of New York.

Cottrell produces about six thousand barrels of beer per year among all of its brands; about 60 percent comes from Cottrell, Buffum said. You can find Cottrell throughout the state and in several other states, including New York, Rhode Island, Pennsylvania and South Carolina. However, the place to check it out is the brewery itself. The high-ceilinged, boxy factory has a small tasting area with enough taps to show off Cottrell's lineup, along with a few to share some beers brewed there. You can also pick up some Faire Ivy Soap, made locally with Mystic Bridge IPA and Stonington Glory Pilsner.

Buffum's interest in history and desire for underwater adventure provides my favorite tidbit about Cottrell. In 2005, Buffum and his diving partners went on the lookout for what Buffum had only read about in books as a child. It was believed that Captain Oliver Hazard Perry—a naval hero in the War of 1812—had wrecked a ship a mile off Rhode Island just prior to the war. Buffum and his diving partners found the remains of the USS *Revenge* and announced their finding to the world, waiting to do so until the 200th anniversary of the wreck, in January 2011. For beer drinkers, the best was yet to come, as the brewery came out with Perry's Revenge, a soupy, sweet Scotch ale named in honor of the wreck.

Reflecting on Cottrell's longevity, Buffum said that it's been due to a mix of pragmatic conservatism and the willingness to work with others. "We stick to one beer and tried to focus on one thing, and I think that was a part of our success," he said. "But for me, contract brewing has diversified our income stream, and that's helped us pay the rent and overhead. Maybe someday we won't do any contracts, and we'll have enough demand and volume for our own stuff…To me, it's just satisfying to say that we've made this with our brains and hands, and here you have this product at the end of the day and you can be at a bar and say, 'We made that beer.'"

The Beer

Cottrell is synonymous with OLD YANKEE ALE, and there's a reason why it has been so successful. It's an amber with a little bite of bitterness, and that balance—along with a relatively low ABV at 5 percent—makes it a beer that pairs well with food and draws craft beer fans and casual drinkers alike. Its MYSTIC BRIDGE IPA is one for the hop-heads out there—with hints of grapefruit from the hops, it's a great summertime beer. For a much more restrained beer that's also made for pairing with seafood or salad, you can try STONINGTON GLORY PILSNER, which is dry and features Czech yeast. The buttery sweetness of PERRY'S REVENGE is my favorite from Cottrell. Weighing in at 8.6 percent ABV, it's a malty black bear hug of a beer.

Stopping by the brewery has its advantages, especially if you're up for experimentation. There are weekly "nano" batches, and past offerings have included a honey porter, a cask of Old Yankee Ale with Sorachi Ace hops and a Rye Double IPA.

Q&A

What is your take on the current Connecticut craft beer environment?

"I think we're full-steam ahead, but the jury is still out about on what kind of volume the state can absorb. There's a note of caution there as well for me. We saw it happen before, around 2000–2001, and before that in general around the country, and there was a bubble and it burst. But demand and awareness and education have increased, and there are more people drinking craft beer now."

–Charles Buffum Jr., owner, Cottrell Brewing Company

City Steam Brewery Café

492 Main Street, Hartford
(860) 525-1600
www.citysteam.biz
Founded in 1997

The Brewery

City Steam Brewery Café, located in a beautiful building in downtown Hartford, is literally powered by steam and figuratively powered by brewer Ron Page. The 350-seat restaurant is part pub, part date-night dining spot and part stand-up comedy destination. There's a lot that's old fashioned about the wide-arched building: massive pipes under the street still run the electricity, and the architecture by Henry Hobson Richardson brings to mind something from ancient Rome. In fact, the building was once the largest department store in Connecticut.

There's diversity in its constantly rotating fifteen taps thanks to Page, who bills himself as the brewer who has been making beer continuously in Connecticut the longest professionally. As a young "hippie" in the 1970s, prior to a law that made homebrewing legal in the United States, Page started making beer based on *The Big Book of Brewing* by David Line. He procured his barley from a health food store and ground it in an A&P coffee grinder, using the only two kinds of dried-out cone hops he could get: Cluster and Bullion.

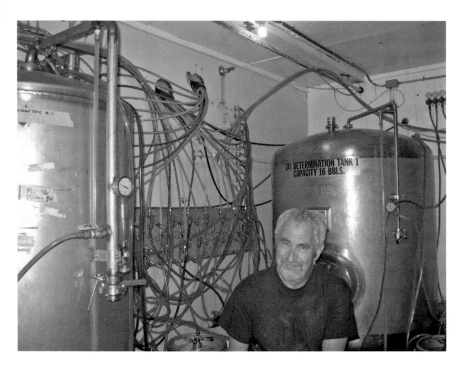

City Steam Brewery Café head brewer Ron Page. *Photo by the author.*

While he experimented with what he could get his hands on in terms of German and English imports, Page continued to experiment with his own beer. In the early 1980s, he joined a group called the Underground Brewers of Connecticut, which opened his eyes even further to the possibilities of creating beer and brought him into the world of homebrew competitions. "It was very good grounding of the grammar of beer," he said. "We were learning how to read music before improvising."

The education paid off. In 1989, Dick King of New England Brewing Company in Norwalk hired Page, who was working as a carpenter, based on his homebrewing experience. He made an India pale ale (Gold Stock, which is the only beer that the "new" New England Brewing Company still occasionally makes), an oatmeal stout and a light lager. After a few years, Page moved on to Elm City Brewing in New Haven, where he worked for two years. From the way Page expresses it, the brewery was not exactly run well. "They did well for two years and they fell apart," he said. "Then I came here."

The only other brewery in town was the Hartford Brewery Limited, a brewpub that did not last much longer once City Steam moved in. "We stuck to our guns and only served the beer we brewed," said Jay DuMond,

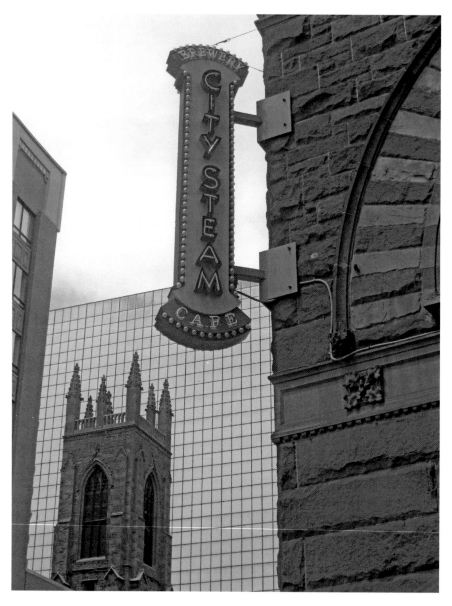

City Steam Brewery Café's sign. *Photo by the author.*

one of the owners of City Steam. "The key was to train our staff so [that] when someone ordered a commercial brand of beer we told them to try our comparable" beer. For the first five years, craft beer was a tough sell, Page said. He even made a low-carb beer in response to the Atkins diet craze (he

called his beer the Chet Atkins). "Beer kept the restaurant alive early on," Page said.

Choices are what you get when you come to City Steam. Page said that he likes to keep a variety of styles on his taps. Like any good brewery, the selections there will swing seasonally, so that you'll get more of a variety of IPAs in the summer and more choices of porters and stouts come wintertime. "Right now, boredom is the big challenge," Page admitted. "I've done almost every kind of brew imaginable. In the end, however, brewing is first and foremost a job. Or a career. Brewing has bought my house, helped fund my future retirement. I hope the idealistic young brewers just starting out realize that after the dream or the passion fades, the day-to-day reality of hard work, temperamental equipment and ever-changing customer preferences are part of a package that all the handcrafted suds in the world cannot entirely make disappear."

The brewery is not without its controversy. In January 2014, Anchor Brewing Company—which makes Anchor Steam—sued City Steam over the trademarked word "steam." The breweries have since reached an agreement, and now the brewery must change its name on packaged beer to one word: Citysteam.

The Beer

Most people know City Steam via Naughty Nurse, the reserved amber ale with the racy name. I'd say that the Blonde on Blonde, an American pale ale, is the best out of the beer available in package stores in the area; its German bittering hops and floral nose helped it win first place in the Pale Ale category at the 2012 Great International Beer Festival in Providence, Rhode Island. The third beer it bottles (and contract-brews at Two Roads Brewing Company in Stratford) is Innocence, an expressive, bitter American India pale ale made with what City Steam calls "an international menagerie of expensive hops."

At the brewery, you're liable to get anything from a light lager (like the barely there Colt 46) to the Black Silk Stout, which is smooth with coffee notes. There's Acapulco Gold, an IPA that pops with citrus and pine taste and is light in body. The Pugnacious Porter is a thick and hearty Baltic porter that displays hints of licorice. For more easy-drinking options, you might go with White Wedding, an unfiltered wheat ale that's as refreshing as a midnight jump in the neighbor's pool.

If you can, get some of MR. PAGE's "Private Reserve" series, which are high-alcohol treats. "Those are beers meant to age," Page said of his creations. "It's a true test of a brewer: can it last a year in the bottle?"

Q&A

What advice would you give to new brewers?

"I don't like to give advice unless it's of a technical nature. Beer is like music… there are only so many notes that can be arranged in so many patterns. That's not to say that all music—or beer—sounds or tastes the same. Just remember, almost everything you create has probably been done before, just a little differently. If I had to tell a would-be craft brewer anything, I'd say, if you're not mechanically inclined, don't even bother."

<div align="right">

–Ron Page, head brewer, City Steam Brewery Café

</div>

SOUTHPORT BREWING COMPANY

2600 Post Road, Southport
(203) 256-BEER
Founded in 1997

850 W. Main Street, Branford
(203) 481-BREW
Founded in 2002

33 New Haven Avenue, Milford
(203) 874-BEER
Founded in 2005
www.southportbrewing.com

THE BREWERY

Southport Brewing Company (SBC) had its genesis when co-owner and brewer Mark DaSilva sat sipping a Samuel Smith's Taddy Porter in the mid-1990s. DaSilva, who was working as a ski instructor and construction worker at the time, began chatting it up with a member of his brother's fraternity at a party in New York City. DaSilva was marveling at how much more flavor it had than other beers he'd tried, and the man at the bar turned out to be Stephan Slesar, a co-owner and brew master at Beer Works, a brewery chain

in Massachusetts. Slesar offered to teach him how to brew at the site in Boston and DaSilva—despite the fact that the gig didn't pay—took him up on it and worked weekends at the brewery.

That experience emboldened DaSilva to talk to his brother, Bill, and friend Dave Rutigliano about finding a space for their own brewery, and they found the perfect-sized restaurant that was closing down. While working with Slesar as a guide, it took about four months to outfit the restaurant and set up the brewing equipment. In April 1997, SBC joined the small community of Connecticut brewpubs and stands as one of the few survivors of a time when owners thought this new "craft beer" thing was going to be a financial hit. "When we opened up, we did not call ourselves a brewpub," DaSilva stressed. "We are a brewery/restaurant…When we opened, we decided that we weren't going to be a burger and nacho place. There was an enormous reaction right away, and we ran out of food the first night."

Despite the knowledge he acquired at Beer Works, DaSilva said that he learned almost everything he knows about brewing on the fly once the first SBC brewery opened. But that wasn't enough for the DaSilvas. Four years later, they opened an SBC in Stamford, and over the years have opened

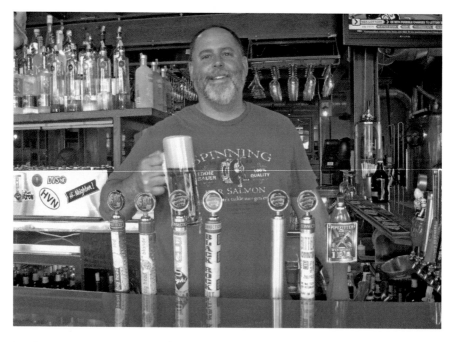

Southport Brewing co-owner Mark DaSilva. *Photo by the author.*

brewery/restaurants in Branford and Hamden, as well as a non-brewing restaurant in Milford.

SBC has gone through its share of changes to keep itself viable. It used to bottle two of its beers at Thomas Hooker Brewing Company but later discontinued the practice, as it was not proving to be a moneymaker. The brothers closed the Stamford brewery in 2014, as it had its Hamden brewery,

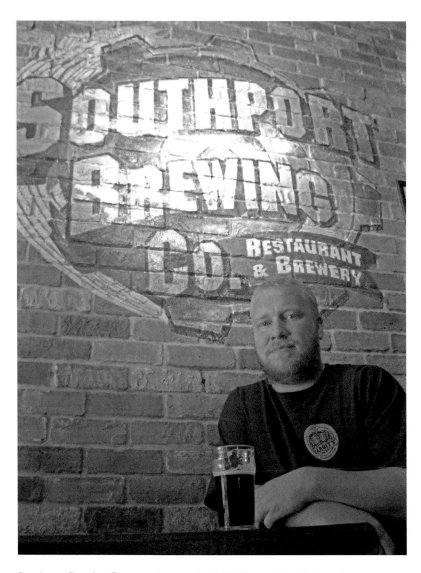

Southport Brewing Company brewer Frank DelGreco. *Photo by the author.*

which was only open briefly. SBC owners have also expanded their reach: in 2011, they opened Sitting Duck Tavern, a small restaurant in Stratford. Two years later, they opened Local Kitchen & Beer Bar in Fairfield and then a sister Local Kitchen in South Norwalk. "There's a certain point where you either grow or you become stagnant," DaSilva said. "I love building. It's one of my favorite things: the design part, the build part."

DaSilva shares his brewing responsibilities with Frank DelGreco, a busboy to whom he gave the same opportunities that were given to him in Boston. After some brewery experience at Magic Hat Brewing in Vermont, DelGreco started waiting tables before shadowing DaSilva and learning what he could about brewing. He eventually took over the Southport location in 2002, which, like the one in Branford, has a seven-barrel brewhouse. The brewers create beers in two lines: their Blue Collar beers and Hydroponic beers. The Blue Collar line, which includes its Connecticut Pale Ale, is made from exclusively American ingredients. The Hydroponic beers are Belgian-style. DaSilva estimates that he's created about one hundred different beers and that he only repeats about half of his beers while tweaking the recipes for others.

Each of the brewery/restaurants has its own qualities. The Southport location, with its two-hundred-seat dining room, is very dark and tucked into a suburban strip mall. It has exposed brick walls and what looks like aluminum siding that makes a slant over the thirteen-seat bar to complete the industrial look. In Branford, which is off a busy road, there's more light in its bar, which steps off onto a patio. The small Milford spot is in more of a foot-trafficked area in a nice little bar-hoppy area.

"Over twenty years I've become a plumber, electrician and engineer here," DaSilva said. "In the middle of the brew, you have to fix things right away. But it's been an incredible learning experience. Every day I wake up, I'm excited to go to work."

THE BEER

SBC makes a wide variety of beer, available at the breweries and on tap throughout Connecticut and in Westchester County, New York. Its most popular are the CONNECTICUT PALE ALE, a copper-colored, gently hopped beer that's balanced, and the HYDROPONIC WHITE, which has more lingering ripe-banana impact and benefits from a refreshing zing from the hefeweizen yeast.

I tried a MAZE lager, which DelGreco said he serves when someone asks for a Miller Lite. It's an honest-to-goodness adjunct beer made with corn and rice, which is not an easy thing to achieve at the microbrewery level. It's as light as the plot of a Disney Channel sitcom. The name has a double meaning: it's like maize, but it's also named for a Phish song, and DelGreco is a Phish fanatic.

There are two wheat beers of note: BIG HEAD RED is sweet and smooth, while the BIG HEAD BLONDE is crisp and floral.

One of the strangest Connecticut beers I've had is MAMBO BOCK, a 10 percent ABV lager. It has double the amount of malt that most lagers do and is brewed only five barrels at a time. DelGreco calls it his Devil Beer, and that 10 percent sneaks up on you.

Q&A

What do you think of the explosion in new breweries in Connecticut?

"I think it's about time. Being in this business for as long as I've been, I've seen the rise and fall of a bunch of breweries. These guys from the past four or five years are solid—they aren't the lawyer who saw beer as a way of making money and hired a homebrewer who never did it before. Hopefully [the new Connecticut brewers] are business people, too. I haven't had a bad beer yet."

–Mark DaSilva, owner and brewer, Southport Brewing Company

Willimantic Brewing Company

967 Main Street, Willimantic
(860) 423-6777
www.willibrew.com
Founded in 1997

The Brewery

As for delivering the brewpub experience, Willimantic Brewing Company offers the complete package. Get it? Package? Because it's housed in a former post office? Anyway, Willibrew is the handiwork of David Wollner, a homebrewer turned restaurant owner who has seen Connecticut beer mature from the quiet 1980s through today. He's built a reputation for professionalism and quirky styles at his brewpub that makes a road trip to the "quiet corner" of the state worth it.

When Wollner moved to the area to attend the University of Connecticut at nearby Storrs, he didn't really like beer. However, after some maturing and visiting pubs with his brother, Wollner fell in love with imported English ales. He started homebrewing with a kit he bought with his brother's credit card and started off by making "awful" beer that tasted at best like "carbonated cider." Wollner took advice from the judges who had to suffer through his creations and was soon making award-winning beer. After meeting the woman who would become his wife (they have since divorced) in 1988, he learned they had

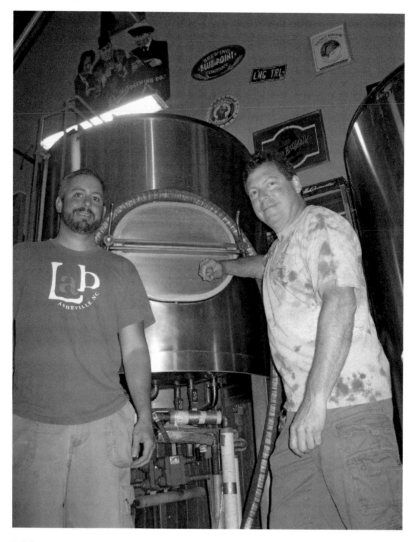

Willimantic Brewing Company brewer Ben Braddock and owner Dave Wollner. *Photo by the author.*

aligned dreams: she wanted to run a pub, and Wollner wanted to make beer. The couple decided to get their feet wet by running a delicatessen at the old Capital Theater building on Main Street in Willimantic, a village in the town of Windham, but they started researching what it would take to run a pub. In 1994, he opened Main Street Café, a bar also on Main Street, that sold American craft beer; however, that was not close enough to the dream.

Wollner cast his eye on the giant former U.S. post office, a granite and limestone behemoth built in 1909. The building—like the other ventures, also on Main Street—had ceased to be a post office by the late 1967 and was abandoned for thirty years, although the town did use it as a haunted house, Wollner said. The Wollners saw potential and started leasing the building in 1997, making major renovations and eventually buying the building outright in 2009. The floor space totals about twelve thousand square feet, about half for the kitchen. The building's immense ceilings, restored walls and grandiose marble floor give it a regal bearing. What was once the post office work room is now the dining room, where you can view the seven-barrel brewhouse through tall windows. The customer lobby is now the pub area, with its sixty-foot mahogany bar.

It was one thing to buy a former federal building and turn it into a brewpub, but it was a whole other thing to actually run it. With no formal training as a brewer, Wollner attended seminars and brewed with the owners of the former Hammer & Nail Brewing Company in Watertown. It was during these early years that Wollner came up with the recipe for Certified Gold, a golden ale that became and remains the brewery's flagship beer. Over the years, as his own tastes changed—from adoring stouts to appreciating the limits of bitterness with India pale ales—so has the expanding tap list. A summer list had nine Willibrew beers on tap, brewed by Wollner and fellow brewer Ben Braddock: the Certified Gold, a beer infused with flowers, three different IPAs, a summer ale, a brown ale, an amber ale and a saison. "When we started, I had to hold everybody's hand and teach them about the beer," he said of his clientele. "People wanted Bud, and I'd give them Certified Gold and it wasn't like Bud." With forty taps altogether, Wollner isn't afraid to share his lines with guest beers. Beer from Willibrew and its guest breweries ends up in the food as well: Porter's Porter from Broad Brook Brewing is in the onion soup, and Thomas Hooker's Irish Red is in the beer butter, for example.

There's a reason why Connecticut has so few brewpubs: they're tricky to manage. Some have come and gone due to mismanagement, but Willibrew remains because it caters to the beer crowd as well as patrons who are mostly there for the food. Wollner understands why no one is going with the brewpub model and opting for small breweries instead. "I don't see people owning brewpubs because of the expenses of a kitchen and ways to maintain," he said. Currently, the restaurant brings in about two-thirds of his business while taking up seven-eighths of the expenses, Wollner explained.

Willibrew prides itself on its traditions and ties to charity. Its Halloween Bash is its biggest party of the year, with music, dancing and prizes for

costumes. It holds about six to seven beer dinners per year, and the first Wednesday of the month is Weird Beer Wednesday, which features beers that highlight the unexpected, like oyster stouts and iced doppelbocks.

The Beer

You'll get a variety of styles at Willimantic Brewing, so you might want to start with a sampler. Working from light to heavy, you should consider starting with CERTIFIED GOLD, a low-alcohol American blonde ale, mellow and clean. WORKING MAN'S WHEAT has a brisk lemony tartness due in part to the Crystal hop. Things get sort of orange with ANYTOWN, USA A.S.B., an "American special bitter." This one is particularly food friendly and even balances out spicy wings.

Willibrew is known for its many styles of India pale ales. Two that come on line regularly are the PUSHING THE ENVELOPE IPA, which has a tropical fruit taste with hints of sweetness for balance, and the EXPRESS MAIL IPA, which has a light body and a more bitter finish.

Two more experimental beers at Willibrew have stuck with me for months. One was FLOWERS INFUSION, a saison that was indeed flowery and almost knocked me over with its perfume-like aroma. Brewers infuse this unfiltered creation with chamomile, calendula, lavender, hibiscus, rosebuds and clover honey. The other was a GHOST PEPPER ale, literally made with the infamous pepper, that is nothing short of devastating to the palate. I couldn't make it through a few sips, but that should not deter the more extreme drinker.

Q&A

What do you personally bring to the Connecticut beer community?

"I'm very open. I'm open to suggestions. For the longest time, I would be hurt if people didn't like something. I think because I'm open to suggestions, I like when people come up with ideas, and that's why I've had employees for fifteen to eighteen years. If I was going to give anybody advice, it would be to do whatever you want to do and have a passion for it."

–David Wollner, owner, Willimantic Brewing Company

OLDE BURNSIDE BREWING COMPANY

776 Tolland Street, East Hartford
(860) 528-2200
www.oldeburnsidebrewing.com
Founded in 2000

THE BREWERY

The least appreciated ingredient in beer is also its most abundant. There's nothing particularly exciting about water, but that doesn't make its quality any less crucial. And for Olde Burnside Brewing, water not only sets it apart from other breweries, but it's also directly linked to its founding. The modestly sized brewery is an extension of the Burnside Ice Company, which was founded in 1911 but has been running out of its current location since 1933. Three generations of McClellan family "icemen" have kept the business going through waves of technology and a changing demand for ice, which comes from a source on their property. By the 1990s, there were plenty of people just coming for the water. It turned out that they were homebrewers after the taste that comes from the water's high alkalinity that's been compared to that from Burton-on-Trent in England.

In 2000, the family decided to form a brewery with equipment they purchased from Wyoming. "When we first started, the brewery wasn't a hobby, but it wasn't the priority it is now," said Jason McClellan, the

Olde Burnside Brewing Company logo. *Photo by the author.*

brewery's operations manager. "Early on, it was fun. There were just three of us: us, Thomas Hooker and Cottrell [brewing companies]. Back then, it was all about getting the older bar owners to agree with you. They understand craft beer now." Olde Burnside capitalized on the McClellan's Scottish heritage, with imagery on the bottles of Celtic crosses and Scottish lions. "Burnside" is Gaelic and means "by the brook"; it's also the name of a section of East Hartford.

Starting with Ten Penny as its flagship Scottish ale, the brewery expanded to include seasonal beers, which included the black-and-tan Dirty Penny Ale and Christmas beers. Among its original brewing team was Paul Zocco, an award-winning homebrewer and owner of Zok's Homebrewing and Winemaking Supplies in Willimantic. McClellan said that the brewery grew "exponentially" during its first four years, and then came a leveling off. "Our sales are amazingly steady," McClellan said. "It's a known brand, and while it doesn't appeal to the beer geeks, it appeals to the masses, from twenty-one to seventy."

The brewery itself is a cramped affair: it's squeezed into three rooms behind Burnside Ice Company, which still operates year-round. It's composed of a 15-barrel Specific Mechanical Systems brewhouse, with nine 40-barrel fermenters and two 10-barrel fermenters for smaller-batch specialty beers. It puts out 3,500 barrels annually, with a capacity for 9,000. In 2014, Olde Burnside took on a brewery, Pioneer Brewing Company, to contract its equipment. It's got some real potential on its own to take off, especially the beers in its high-alcohol imperial series: a "double American brown ale," a "double Vienna lager" and an India pale ale.

The best place to enjoy Olde Burnside ale onsite is its "brew-tanical" garden: a little tented wooden oasis just off the garage in the back of the property where you can sit on a stool and chat with the brewer or trade stories with fellow drinkers. On Saturdays, the brewery often has hot dog trucks to fill you up while you sample.

THE BEER

Old Burnside's offerings make for nice food pairings, primarily because most of them don't call attention to themselves very much. TEN PENNY ALE is a mild Scottish ale with just a hint of roast. It incorporates beechwood smoked malt from Germany and pairs well with burgers and steak. For an even more malty experience, there's DIRTY PENNY ALE, a black and tan that blends Ten Penny with a stout. The combination yields a slightly sweet result, which makes it an appropriate pairing for barbecue as well as German chocolate cake.

PENNY WEIZ, a "Belgian-Scottish witbier," comes from a collaboration between head brewer Joe Lushing and Zocco and incorporates heather tips and orange peel. If you like a wheat beer that pairs well with fish dishes, you've found it. Olde Burnside ventures into other foreign territory with its HOP'T SCOT, an English IPA that features Target, East Kent, Golding and Willamette hops. With a pinch of smoked malt, this slightly bitter ale is perfect with spicy dishes or by itself.

You can experience more limited releases by visiting the brewery itself. MONS MEG, a double IPA that's a hop monster, is a limited release that parades Columbus hops for bittering and Citra hops for aroma.

Q&A

How has the beer industry in Connecticut changed since 2000?

"There's more competition now. I think the beer culture is still in development in this state outside of the Interstate 91/95 corridors. The bar owners are more receptive, but there's still just one local line, maybe two…I think the beer people in the state aren't loyal to Connecticut beers. They're loyal to whatever's hot."

–Jason McClellan, operations manager, Olde Burnside Brewing Company

Thomas Hooker Brewing Company

16 Tobey Road, Bloomfield
(860) 242-3111
www.hookerbeer.com
Founded in 2003

The Brewery

If the Connecticut breweries were one big family, Thomas Hooker would be an older brother who still loves to have a good time but shoulders a lot of responsibility. Taking on the role of a leader makes sense for a brewery named after a colonial clergyman who helped found Hartford in the 1630s. Thomas Hooker started off life in the 1990s as Trout Brook Brewhouse in Hartford. It made a variety of its own beers during a brief period when the city supported three brewpubs; however, after three years, the Parkville section brewery ceased its operations in 2000.

Enter Curt Cameron, a liquor store (or, as Connecticut folks call it, "package store") owner with an interest in starting a new venture. He revived the brewery in 2003 and renamed it after Trout Brook's Thomas Hooker Ale. In 2007, he took the brewery from its two-thousand-square-foot space to an eight-thousand-square-foot space in industrial Bloomfield, just north of the city. Recently, the brewery expanded further still, purchasing a nearby building for storage and creating an impressive visitors' center and patio.

Drinkers enjoy a Thomas Hooker Brewing Company open house. *Courtesy of Thomas Hooker Brewing.*

Thomas Hooker also uses some of its fifteen fermenters and six brite tanks to make beer for others under contract, including Relic Brewing of Plainville and Weed Brewing of Cheshire, along with out-of-state breweries. It's a tall order for the four full-time brewers on staff.

Thomas Hooker's latest head brewer is twenty-one-year-old Sean Piel, a Connecticut native who trained in England and Germany—where he was old enough to receive training—before returning to his home state to work full time. Piel started homebrewing with his father when he was fourteen and left to take the courses right after high school. "It was different from American breweries," he said of his time in England. "It's all cask beer there, with open fermenters. The school was a lot of theory and a lot of internships at other breweries." After that fourteen-week course, Piel traveled through Europe and eventually landed in Mallersdorf-Pfaffenberg in Germany's Bavarian region. He worked at Gasthof Stöttner, making traditional styles, including doppelbocks, hefeweizens and lagers. "I would wash kegs, starting

at 6:00 a.m. and ended at five in the evening," Piel said. "I stayed in a room above the brewery."

The Bloomfield brewery that has become Piel's workshop is more than a place to make beer; it's a meeting space where Thomas Hooker regularly hosts open houses. On Friday nights, people can be seen lining up for samples and contributing to good causes. Donations on these nights are routinely passed along to the Village for Families & Children, a Hartford organization that provides homes for neglected children. Cameron was himself an adopted child and holds the group in high esteem. Businesses and other organizations regularly use the space for gatherings. With a capacity for three hundred people, the brewery had close to one hundred gatherings in 2013 and about twenty-five thousand visitors.

Thomas Hooker also opened what it calls its "test kitchen" at the Mohegan Sun Casino in Uncasville. It's technically an eight-barrel extract system, where small batches of experimental beers get fermented after being brewed in Bloomfield. Brewers have fermented a hefeweizen there, along with a chocolate pumpkin stout.

Cameron plays another important role in the scene: he's the head of the Connecticut Craft Brewers Guild. This informal group brings brewers together to organize promotions of craft beer in the state. It's come along at the right time, with an explosion of breweries since 2010. "We're late to the game," Cameron said of Connecticut breweries, "but we're catching up quick."

The Beer

Hooker has year-round offerings that are solid and perhaps a bit conservative. Its Blonde Ale, which incorporates some wheat, is crisp with a touch of sweetness from the malt. Even more laidback is the Munich Lager: at 4.8 percent ABV, this traditional German helles-style beer is particularly refreshing, and you're able to have a bunch of them. For bigger beers, I'd hunt down Hooker's Liberator Doppelbock, a rich, sweet lager that caresses the tongue in cocoa-flavored goodness. The brewery also makes Hop Meadow IPA, Irish Red and Imperial Porter among its year-round lineup.

Seasonally, Thomas Hooker takes more chances and gets particularly diverse. In the summer, there's the Watermelon Ale, which over the years has tasted slightly different—sometimes having more aroma and sometimes

none at all. It's made with "watermelon extract," and this pink concoction is one of those "love it or hate it" beers. Come fall, Hooker makes a solid Octoberfest, an amber lager that pairs well with hearty German sausages. The wintertime Nor'Easter Lager has a gentle spiciness, but there's nothing gentle about the Chocolate Truffle Stout, made with ingredients from Munson's Chocolates of Connecticut—it's a sweet-tooth's dream.

As for limited releases, Hooker goes out of its way to create some special offerings. Old Marley Barleywine-Style Ale, for example, is oak barrel–aged and just warms you to the core at 12 percent ABV. Piel has also introduced Belgian-style ales, my favorite being Demure, a smoked saison. The delicate smokiness from the pre-smoked malt plays so well with the saison sweetness that you feel transported to a little cabin in the Belgian woods in front of a roaring fire.

Q&A

What are some of the biggest challenges you've faced along the way with the brewery?

"I guess the big challenge with any brewery that grows is equipment. The bottling line can be a source of frustration. It's also hard to find staff; you want to make an organization successful and with people who want to be here. We have a great bunch of folks working at all levels of the brewery… The challenge any brewery has is when you make beers only for yourselves. For example, even though the Watermelon Ale is not my pick for a beer, a lot of people like it. It affords us to make doppelbocks and barleywines that give us street cred."

—Curt Cameron, owner, Thomas Hooker Brewing Company

CAMBRIDGE HOUSE BREWPUB

357 Salmon Brook Street, Granby
(860) 653-2739
www.cbhgranby.com
Founded in 2005 (changed ownership in 2009)

THE BREWERY

Scott Riley, the owner of Cambridge House Brewpub, is a practical guy who exudes the kind of unassuming competence that reflects his midwestern roots. The Wisconsin native with a background in biotech engineering came to Connecticut as a manager who specialized in making sure companies complied with environmental regulations. "I was looking for something to do on my own," he said, passing the time with me at one of the tables just off the bar. What better place to take his informal homebrewing experience and attention to detail than a brewpub?

Riley found one for sale that was going through troubled times. A group of partners had opened Cambridge House in 2005, and all seemed to be working well for the collaborators, at least from the outside. In 2008, a co-owner launched a sister Cambridge House at the site of a former department store in the small city of Torrington, about twenty-five miles away. This was in the middle of an economic recession, and the Granby location suffered first. It went up for sale, and because of his lack of experience, Riley had to

Cambridge House Brewpub owner Scott Riley. *Photo by the author.*

have a partner with restaurant experience before a bank would even consider lending him money. He did so and basically picked up where the last owners left off. In 2010, Cambridge House in Torrington closed down, severing ties with the original ownership.

In Granby, Riley (who is now the sole owner) had to make a few improvements for upkeep's sake; otherwise, Cambridge House has not changed much at all since he took over. Riley kept up the tradition of a mug-club, which has two hundred members. He started with the brewery's existing brewer, who later moved to Oregon. Then Riley worked with two others before finding Mike Yates, who continues to make beers that started at the original pub, like the India pale ale and the kölsch.

Cambridge House is a friendly, laidback, English-style pub with a twenty-five-seat, U-shaped bar and enough tables to seat about eight to ten

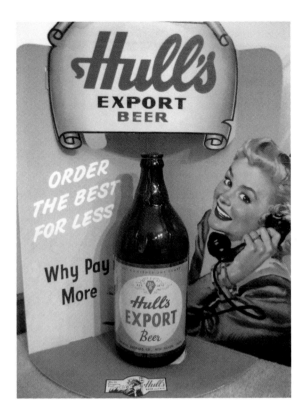

Left: An original bottle from the Hull Brewing Company, along with a vintage advertisement, belonging to George and Dale Miller. *Photo by the author.*

Below: A coaster from the former Cremo Brewing Company of New Britain. *Courtesy of George and Dale Miller.*

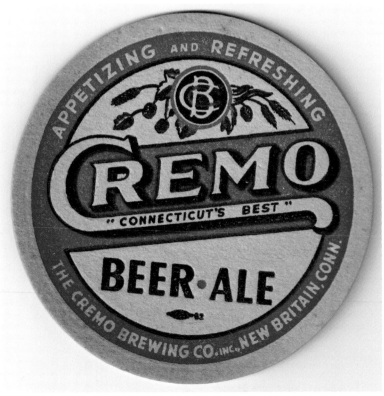

Coaster from the former Hammer & Nail Brewing Company of
Watertown. *Courtesy of Ed Breare.*

Coaster from the former Olde Wyndham Brewery of Willimantic. *Courtesy
of Ed Breare.*

Coaster from the former Troutbrook Brewing Company of Hartford. *Courtesy of Ed Breare.*

Snifter from OEC Brewing Company. *Courtesy of OEC Brewing.*

Above: Cambridge House Brewing Company sampler. *Photo by the author.*

Left: The end of the bar at Firefly Hollow Brewing Company. *Photo by the author.*

Some flights at Firefly Hollow Brewing Company. *Photo by the author.*

A "squealer" from Relic Brewing Company. *Photo by the author.*

Relic and Beer'd brew the companies' label for Nano-a-Nano, their collaboration beer, designed by Gary Holmes. *Courtesy of George and Dale Miller.*

Back East Brewing Company cans. *Photo by the author.*

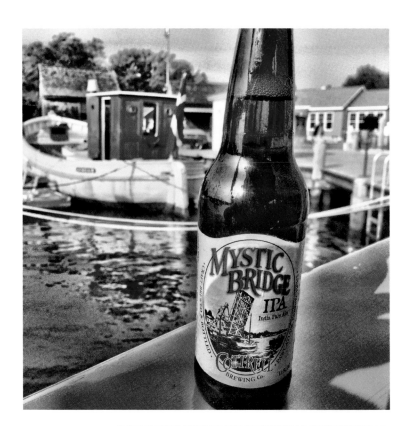

Above: Cottrell Brewing Company bottle of Mystic Bridge IPA. *Photo by Bergin O'Malley.*

Right: Bottles of Two Roads Brewing Company's Road Jam. *Photo by the author.*

Left: The exterior of Willimantic Brewing Company, a former U.S. Post Office. *Courtesy of Willimantic Brewing.*

Below: Half Full Brewing Company's Bright Ale. *Photo by Jordan Giles.*

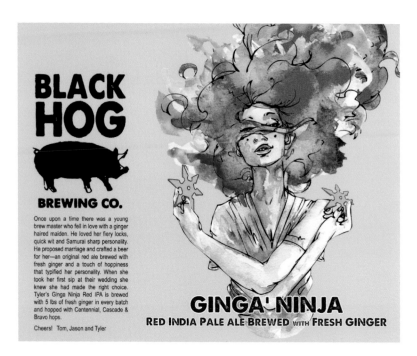

Black Hog Brewing Company's Ginga' Ninja label, designed by Maximilian Toth. *Courtesy of Black Hog Brewing.*

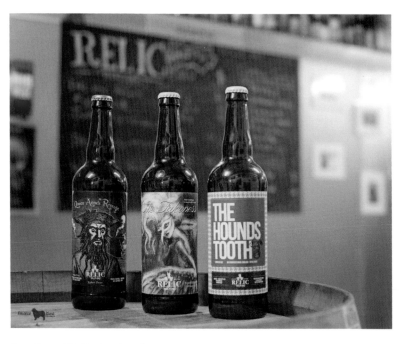

A variety of Relic Brewing Company bottles: Queen Anne's Revenge, The Falconess and The Hound's Tooth. *Photo by Roxanne McHatten, Gura Photography.*

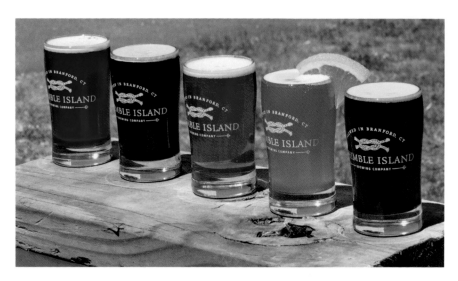

A Thimble Island Brewing Company sampler. *Courtesy of Thimble Island Brewing.*

Two Roads Brewing Company's No Limits on the canning line. *Courtesy of Two Roads Brewing.*

Right: Shebeen Brewing
Company's Cannoli
Beer. *Courtesy of Shebeen
Brewing.*

Below: Conor Horrigan,
head of Half Full
Brewing Company. *Photo
by the author.*

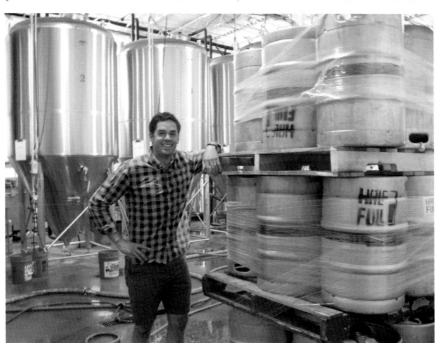

Left: From the front of BruRm @ BAR in New Haven. *Photo by Bill Mill/Flickr.*

Below: Thomas Hooker Brewing Company head brewer Sean Piel. *Courtesy of Thomas Hooker Brewing.*

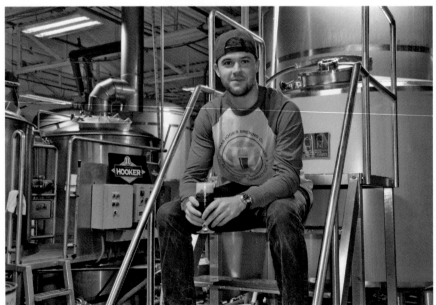

Above: The mural in Thomas Hooker Brewing Company's brewhouse. *Photo by the author.*

Right: The brewhouse at OEC Brewing Company in Oxford. *Courtesy of Ben Neidart.*

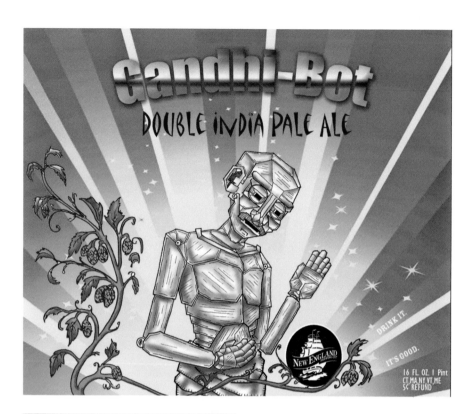

Above: New England Brewing Company's Gandhi-Bot label, designed by Craig Gilbert. *Courtesy of New England Brewing.*

Left: A bottle of Relic Brewing Company's Antiquity. *Photo by Roxanne McHatten, Gura Photography.*

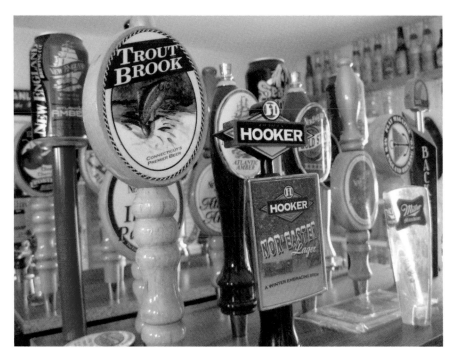

A variety of Connecticut beer tap handles belonging to George and Dale Miller. *Photo by the author.*

Various cans of beer brewed in Connecticut, belonging to George and Dale Miller. *Photo by the author.*

Left: A variety of Connecticut beers at Coastal Wine & Spirits in Branford. *Photo by the author.*

Below: A tasting room sampler of Stubborn Beauty Brewing beers. *Photo by the author.*

families comfortably. There are five televisions in the pub room, but they are mercifully muted. A side room separated by windows seats tables for four and sports dart boards. Right off the bar is the brewery; in there is a seven-barrel brewhouse, with three seven-barrel fermenters and one fifteen-barrel fermenter, placed prominently in the restaurant's front window. Upstairs, there's a quiet place to eat that feels a mile away from the bar. During the summer, diners can enjoy a wide deck off the back parking lot.

Riley projects quiet confidence and seems to be storing up his words for another time, which is rare for a man in the brewery world. Although he does not brew professionally, Riley has plenty of opinions about how the brewery's beer should taste. I asked him for a recommendation, and he suggested a blend: one half oatmeal stout, one half IPA. It was delicious—creamy, with a lively citrus bite.

The Beer

If you were to create the perfect flight of Cambridge House beers, it'd behoove you to start with the Kölsch, a clear, clean, smooth lager with a baby hop bite and only 5 percent ABV. Creeping up the bitternesss scale, you'd come to the Alt 45, a malty, chalky brown ale. The brewery's American Pale Ale is rather mild compared to the IPA, which has a delightful citrus nose with a grapefruit juice tang that lovingly lingers on the tongue like the last guest at the birthday party who offers to help clean up. Sitting like a liquid cookie and showing off a rich brown coat is the Oatmeal Stout, which you'd enjoy on its own or with a sweet dessert. Among its seasonals, the Summer Wheat is a winner. This 5.3 ABV hefeweizen has a malty backbone and a residual sweetness from the wheat.

Q&A

What advice would you give someone who was interested in running a brewpub?

"You have to be diligent; you have to be engaged. It's not a part-time job. One of the strangest things is that I drink a lot less now than I did before I bought the place because it's hard to stay on top of everything drinking

a lot. Having a couple ounces is not like having a couple pints. Inventory control is important, and staff management is key. You have to be consistent in those areas. That goes with the business. Constant variety is good; you have to keep people interested. But people want to come in and be part of the comfort. It's like your favorite chair at home. If you keep changing it, it won't be your favorite anymore."

—Scott Riley, owner, Cambridge Brewhouse

Back East
Brewing Company

1296A Blue Hills Avenue, Bloomfield
(860) 242-1793
www.backeastbrewing.com
Founded in 2012

The Brewery

Making the customers' taste buds happy runs in the family for Back East's co-founders. For seventeen years, Tony Karlowicz's parents ran the Sweet Occasions candy store in Bloomfield, and while their son made a detour as an accountant in the insurance business, it was partnering with cousin Edward Fabrycki Jr. that brought him back to the family tradition of pleasing patrons. It was over a dinner conversation that Karlowicz and Fabrycki—who had not seen each other for years—realized that they had been contemplating the same dream of owning a brewery.

While Karlowicz brought number-crunching expertise to the equation, his cousin contributed the hands-on experience. A professional engineer, Fabrycki moved from Connecticut in the 1990s to San Diego, where he worked in land development engineering. So, while his cousin was getting his business degree and soaking in the craft beer scene in Vermont, Fabrycki was homebrewing in the West Coast craft beer capital. "While living in San Diego, I was inspired by the sheer breadth of different craft beer and brewpubs available," Fabrycki said.

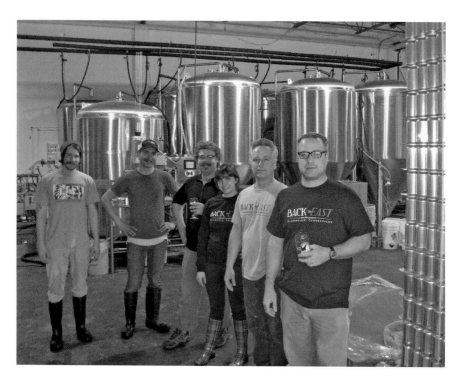

The crew of Back East Brewing Company prior to an expansion. *From left*: Bryce Casavant, packaging assistant; Matt Paonessa, assistant brewer; Mike Smith, head brewer; Jamie Farrell, tasting room manager; Ed Fabrycki, co-owner; and Tony Karlowicz, co-owner. *Photo by the author.*

Fabrycki moved "back east" in 2001, and five years later, the cousins were brewing their own beer together. The challenge was not creating exciting beer but rather replicating it. When it came time to make the leap from amateur to pro, Karlowicz took the lead in creating the business plan, while Fabrycki researched the equipment they would need. After pitching their startup to family and friends, they made their home in an industrial space and got it up to their plumbing and electricity standards in six months.

It was adding head brewer Michael Smith that brought the team together. Smith, who is from Cape Cod, brought with him years of experience at Boston's Harpoon Brewing Company and Plymouth, Massachusetts–based Mayflower Brewing Company. "I tend to be on the traditionalist side in making our beers and designing recipes," Smith said. "My aim is to make good, solid interpretations of our various styles rather than blow folks out of the water." That doesn't mean he's stuck to a script. Smith has explored different hopping techniques, like adding

hops at different temperatures to bring out subtle hop character. He also ages beer in barrels.

Back East boasts a ten-barrel brewhouse. It sold two thousand barrels in 2013 and is planning to build out from its 4,500-square-foot space to accommodate twice that amount. It has a small, pleasant tasting room that fits about forty people, with a few tables for contemplation and easy access to merchandise and brewery tours.

The Beer

I'll show my bias right away and say that Back East's PORTER is one of the best of its style you'll ever drink. It's got subtle caramel sweetness, it's nutty and it boasts a tiny spark of hops at the finish.

The porter joins Back East's other year-round beers, which are canned in six-packs. The balanced, crisp GOLDEN ALE is only 4.9 percent ABV, which makes it a refreshing beer between mowing the lawn and whacking the weeds. BACK EAST ALE is a balanced, quiet amber ale, while the MISTY MOUNTAIN IPA presents a more aggressive piney taste through its hops, although it is by no means a bitter bomb.

Back East also has seasonal beers, available by the growler and on draft. The SUMMER ALE is dry-hopped with Citra, Galaxy and Simcoe hops, so if you're into a citrus aroma and don't mind a strong bite, this one's for you. In the fall, there's Back East's OCTOBERFEST, which stays traditional, with German malts and hops. To sweeten up stubborn New England winters, there's WINTERFEST, made with cinnamon and honey. SPRING ALE, an Irish red, welcomes nature's renewal; this Biere de Mars includes wheat and dried lemon peel.

Finally, the "Hammer of the Gods" series currently includes two beers. The aptly named PALATE MALLET is an American double IPA and boasts four American hops, but don't be frightened of the name—your tongue will survive another beer in the same sitting. On the opposite end of the flavor spectrum is the first beer I ever had from Back East, a double-barreled malt monster that's practically gooey: its IMPERIAL STOUT. The Palate Mallet comes in four-pack cans, and the stout you can get in 750ml bottles.

Q&A

What's the secret to a successful partnership?

"The secret is knowing your business partner very well before you embark on a venture. You need to make sure you both have similar goals and are on the same page as far as what you want to put into the business and what you want to get out of it. You need to have skills, interests and strengths that complement one another. You don't want a partner exactly like you. You also need to figure out what each person does best and be able to rely on each other to let each person do what they do best."

<div align="right">–Tony Karlowicz, co-owner, Back East Brewing Company</div>

Thimble Island Brewing Company

53 East Industrial Road, Branford
(203) 208-2827
www.thimbleislandbrewery.com
Founded in 2012

The Brewery

Information technology folks are known for their ability to target and solve the problems that befuddle the rest of us. While there's a world of difference between managing a computer system and launching a small brewery, it's all about problem solving. That's the attitude of Thimble Island Brewing Company's Justin Gargano and Mike Fawcett, two IT guys turned roommates turned brewing partners.

After eight years of homebrewing, the self-taught thirtysomethings paid for setting up a small brewery in an industrial park with their own money. They kept their day jobs while they toiled away at a two-vessel, ten-barrel brewhouse. "There were issues with carbonation at first," said Fawcett. "A lot of time was spent on the art of carbonating." The problem solvers learned how to fine-tune mash temperatures (how hot the water needs to be when the grain is added) based on the style of beer they were making. There was definitely a learning curve after making five-gallon batches, the co-brewers said.

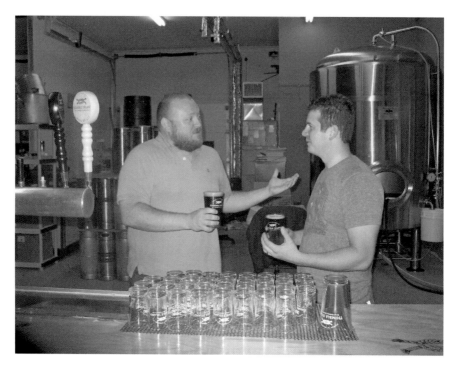

Thimble Island Brewing Company co-owners Mike Fawcett and Justin Gargano. *Photo by the author.*

They built their brewery in their hometown of Branford, a shore town just east of New Haven, and named it for a cluster of islands nearby. The town has since become the home of two other breweries: Stony Creek Brewing and DuVig Brewing, making it the only one in the state to have more than two breweries. Certainly location has a lot to do with its popularity—being situated right off Interstate 95 helps, and being close to a lot of colleges in and around New Haven also has its perks.

"It's very attractive here," Gargano said. "There are a lot of amenities and a high density of restaurants. It's a drinking town; people are into beer and wine. It's always been a place with vacation homes...Plus, our water source is fine." Thimble Island has plans to expand to a new facility and possibly can its beer.

The Beer

Thimble Island makes three beers on a regular basis and then makes more experimental beers (known as its "Uncharted" series) sporadically in smaller batches. Its AMERICAN ALE is a balanced amber that's very sessionable at 5 percent ABV. It's got an aroma of freshly baked bread, a gentle caramel sweetness and a lightly hopped finish. Its INDIA PALE ALE is also balanced; the trick is creating a strong enough malt profile to go up against the citrus taste that comes from the Cascade, Northern Brewer and Falconer's Flight hops.

The COFFEE STOUT, which started as a winter seasonal, turned out to be one that drinkers wanted year-round. It's got a pleasant coarseness to it that comes no doubt from the whole coffee beans from Willoughby's, a Connecticut coffee roaster. You're not going to find much of a hop presence here, and that's when imbalance is deliciously fine.

Q&A

How do you compete in a market that's getting ever more crowded?

"There's a lot of interest [in our beer] now, and it's creating a lot of beer awareness. It's important that we continue to do that for the highest probability of survivability. There's a modern boom going on, and there's only so much shelf space. As long as we continue to raise the consumption rate, it will allow this boom to continue…A lot of beer consumed in the state is domestic, and we've been successful at it, along with Thomas Hooker [Brewing Company] and New England Brewing. It's just about awareness—getting people to try it. There's the fun, crazy beers, but at the end of the day, you have to make more simple beers because that's what the market wants…We're all about the beer community: we want you to support Relic and Beer'd, but we want you to come back to us as your go-to beer."
–Justin Gargano, co-owner and brewer, Thimble Island Brewing Company

Beer'd Brewing Company

22 Bayview Avenue #15, Stonington
(860) 857-1014
www.beerdbrewing.com
Founded in 2012

The Brewery

While craft breweries are making noise in the central and southwest parts of Connecticut, you still don't hear much from the other corners of the state. For many years, it was just Cottrell Brewing Company in Pawcatuck on the lonely outpost near the Rhode Island border way out east. That changed in 2012 when Mystic local Aaren Simoncini combined a well-calculated dream with generous facial hair to add Beer'd Brewing to New London County's portion of the map.

Simoncini studied accounting at Rochester Institute of Technology in New York State, but it was a class he simply took for the credit that would play a role in his professional career. The class, called "Beers of the World," introduced the casual beer drinker to Czech pilsners, the dark ales of England and Belgian delights. The bitter hoppiness of West Coast beers, in particular, inspired the scholar, and not only did Simoncini do well in the class, but it got him on a path toward experimenting with whatever beers he could get his hands on. This contributed to a healthy homebrewing habit at

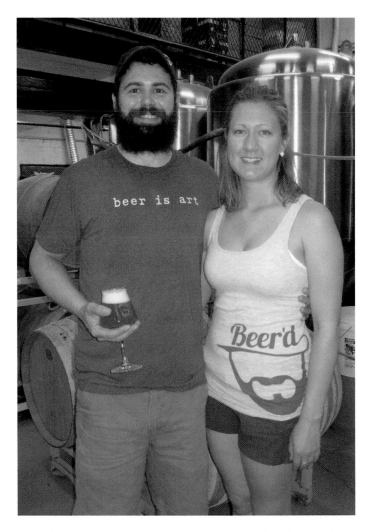

Beerd Brewing co-owners Aaren Simoncini and Precious Putnam. *Photo by the author.*

college. "I started on the kitchen stove and clogged up the sink with hops," he said.

The time wasn't right to go pro yet, so after moving back to eastern Connecticut and working a job as an accountant, Simoncini was able to swing some very flexible hours so that he could pursue his passion. He apprenticed at Cottrell Brewing and was helping make beer right away. This meant brewing on an irregular schedule, sometimes starting a batch at two

o'clock in the morning. He did everything from wash tanks to make sales. "Ultimately, I knew I wanted to do my own thing," Simoncini said.

When it was time for Simoncini to open his business, it was done with a lot of forethought and in a creative space. The accounting major was able to self-finance the venture with his business partner, Precious Putnam, and for six months, he held down his day job before officially cutting ties. "It was about doing things by mitigating risk," he said. Beer'd, which comes from a name Simoncini had been tossing around since his homebrewing days, emerged as one of several businesses housed in a converted velvet mill in suburban Stonington. The former A. Wimpfheimer & Bro. plant is a sprawling, two-story structure that serves as a mall for artistic businesses, including galleries, photography studios and a glass artist. His space was actually where the mill had its boiler room, and there are still coal chute doors in the wall; later, it was used for putting velvet on spools.

Without boasting, Simoncini explained that Beer'd was an instant hit. "We were able to sell enough beer, shirts and other merchandise to fund more equipment." This meant Simoncini was brewing four to five batches a week, while Putnam handled all the front-of-house duties. As of this publication, Beer'd was planning to double its area by purchasing space adjacent to the original brewery.

The three-barrel, electricity-powered brewhouse is about the size of a small deli, with a shallow tasting area and stainless steel vessels crowded together behind the counter. When you arrive for a tasting, it's hard to say what you'll get; in two years, Simoncini had created thirty-four different beers, including a few barrel-aged offerings. This was not just the result of a brewery with style-commitment issues. "Craft beer drinkers are fickle," Simoncini said. "At this level, if I can play with different styles, I will. If I don't like it, I just won't make it again." By his own estimation, however, Simoncini said that he leans heavily in the hop-forward direction: India pale ales and double IPAs are favorite styles. He's also collaborated with other breweries. For example, he made a dark Belgian-style ale with Relic Brewing (Nano-a-Nano).

THE BEER

The tap list at Beer'd is always changing, but there are a few wonderful beers that like to make repeat visits. For example, WHISKER'D WIT is a complex, refreshing Belgian-style wheat beer made with Trappist yeast

and orange peels that's great in the spring and summer. For those who crave the rush of wine-like fruitiness, there's HOBBIT JUICE, a 9.2 percent ABV IPA that uses Nelson Sauvin, a hop from New Zealand (where the *Lord of the Rings* movies were filmed). A personal favorite is 8 DAYS A WEEK, an American pale ale that uses just one hop, Citra, which brings out a kind of grapefruit/orange explosion.

More mellow beers include ELIHUE (named for a nearby street), which is a fifty-fifty wheat/pilsner malt ale, with mostly Amarillo hops, and has a bready/earthy character. There's also WORLD AT LARGE, a quieter pale ale that's very floral and smooth-drinking. If you're lucky, you can time your visit when it has its bottled beers that have been barrel-aged.

Q&A

What's the strangest thing that's happened at Beer'd since you've opened?

"We didn't open our doors to the public until November 2012, just after Hurricane Sandy blew through. Our first batches were actually fermenting during the storm, and our close proximity to the ocean was very worrisome to us as new brewery owners. Prior to the storm, we battened down the hatches and crossed our fingers. We even went as far as purchasing an emergency generator so that we could at least run our cold rooms in the case that we lost power. We did, in fact, lose power during the storm for a few days; however, luckily enough, for us most of our primary fermentations had ceased during that period of time. We did, however, have a hard deadline for our Founders Club party, and as such we had to don our headlamps and brave the roads to make it into the dark brewery to complete our dry hopping activities. Needless to say, we hope we never need to do that again."

—Aaren Simoncini, owner, Beer'd Brewing Company

Half Full Brewing Company

43 Homestead Avenue, Stamford
(203) 658-3631
www.halffullbrewery.com
Founded in 2012

The Brewery

A lot of new breweries, somewhere on their websites or maybe on the back of their T-shirts, share a philosophy. It's oftentimes something along the lines of "Be unique" or "Be extreme." For Half Full Brewing, the philosophy incorporated right into the name seems to fuel the whole operation. While being optimistic isn't a revolutionary idea, it's a natural fit for the principals of the venture: owner Conor Horrigan and Jennifer Muckerman, who serves as head brewer for the young, twenty-barrel brewery known for a beer called "Bright Ale."

The dream that would become the reality of Half Full began in 2008 for Horrigan who, after four years working a Wall Street banking job, decided during a trip to Prague that he wanted to make his life count for something beyond making money. "This brewery wasn't going to be like other breweries, named after a person, a town, mountain, street, or an animal," Horrigan wrote on the brewery's website. "No, I wanted to be a brewery that made you think, philosophize, and feel." In the four years that followed, Horrigan earned his master's in business administration at the University of

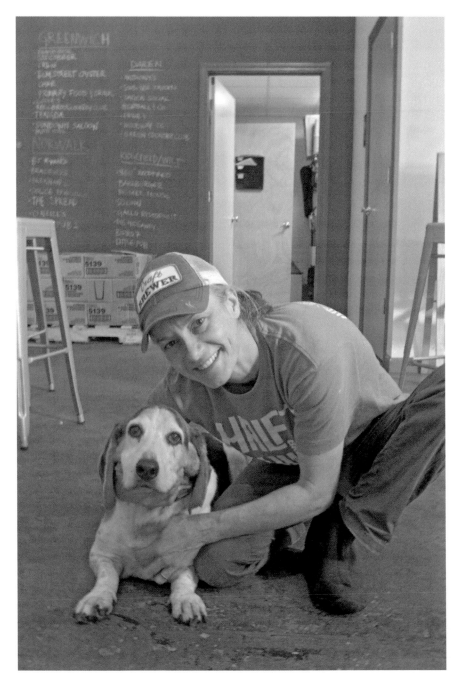

Half Full Brewing Company head brewer Jennifer Muckerman and her dog, Barnaby. *Photo by the author.*

Connecticut, wrote the business plan that would attract the right investors and broadened his homebrewing experience to include an apprenticeship of sorts under the tutelage of Rob Leonard, owner of New England Brewing Company of Woodbridge.

Bootstrap-pulling aside, Horrigan knew that beer was ultimately going to sell the company, not just positive imagery. Field research that extended as far as Australia yielded this idea: make a hoppy beer that isn't too bitter, something that's light. It was down under where Horrigan tried Fremantle, Australia-based Little Creatures Brewing's Bright Ale. He lifted the name "Bright Ale" but changed up the hop profile to make what's essentially a mix between a blonde and a dry-hopped pale ale: clean, a bit juicy and very easy to drink.

Horrigan knew that he needed a head brewer who could articulate his vision, so he auditioned three by having them make a beer on a small system in the brewery. When he was done, it was no contest. Muckerman hailed from St. Louis, where her grandfather had worked as a brewer at the former Falstaff Brewery. "I grew up a Catholic school girl in St. Louis, which means you drank beer," Muckerman said. She worked her way to head brewer at Trailhead Brewing, a brewpub in St. Charles, Missouri. After earning her master brewer's program certification from the Siebel Institute of Chicago, she had an unfulfilling experience in Knoxville, Tennessee, at a contract brewery before making the move to New England. "Conor's attitude is very contagious," Muckerman said. "He was passionate about what he wanted to do." Muckerman works with assistants Laura Infznger and Jon Charest.

Half Full sits in the Riverside section of Stamford, squished into an industrial park. When you enter, you step down into a long tasting room that boasts a large communal table that's only a few feet from the bar. There, visitors who make it to "rare beer" nights every third Wednesday of the month are not only favored with the brewery's three main beers, but they can also try ones that were made in smaller batches. Experimental beers have included a kiwi ale, peanut butter hefeweizen and a rauchbier (beer made with smoked malt). Other attractions include open houses every other Friday night.

The Beer

If you like your ales on the light side with a slight grapefruit kiss, the BRIGHT ALE is probably for you. Made with centennial hops, it pairs well with light salads and seafood. The PURSUIT IPA is made with rye, which gives it a spicy

complexity that gives you more to focus on than bitterness. The 7 percent ABV beer is made with the Cascade hop for flavor and dry-hopped with Columbus for aroma. The third regularly available beer is the TOASTED AMBER, which has a gentle maltiness to it. All three are available in cans.

Q&A

Does it make any difference that you are one of the few female professional brewers in the state?

"I've never noticed a difference. It's not something I've ever focused on. Perhaps other people have focused on it more, but I haven't. One of the advantages is the Pink Boots Society [an organization that supports female brewers]. Women tend to network a little bit better. Women also tend to see it as if we are fighting for shelf space [not just working with other breweries as if they were partners]. Women are more realistic."

–Jennifer Muckerman, head brewer, Half Full Brewing Company

Relic Brewing Company

95B Whiting Street, Plainville
(860) 255-4252
www.relicbeer.com
Founded in 2012

The Brewery

Relic Brewing is an anomaly in Connecticut. It's a tiny, one-man operation that in less than three years produced eighty-two different beers, many of them in small batches. To say that owner/brewer Mark Sigman has a thing for diversity is putting it mildly—from his modest industrial park nanobrewery (a scaled-down microbrewery), which began as a one-barrel system, he's produced black lagers, IPAs, stouts, several Belgian-style beers and more.

Sigman, a Connecticut native in his early forties, opened his brewery in early 2012 after years of travel and experimenting with beer. In the mid-1990s, Sigman was living in Wyoming and getting caught up in the craft beer movement that had taken hold in the western United States. After becoming a permanent fixture at a brewery in Jackson Hole, he moved on to brewing his own beer at home. During this time, he was hopping discounted flights to countries all over the world, sampling beer in Germany, Belgium, England and Tanzania. He moved to Denver in 2000 to get his master's

Relic Brewing Company tasting room. *Photo by Roxanne McHatten, Gura Photography.*

degree in computer programming and found his way back to Connecticut seven years—and many beers and countries—later.

"When I came back to Connecticut, I immediately started just trying everything I could," Sigman said. "Then I started brewing styles that I wanted to drink. I'd brew up to three times in a weekend." In sometimes as small as 2.5-gallon batches, Sigman started making beer that would later become Relic favorites, like Hound's Tooth (a low-alcohol English dark mild) and Prologue, a rye beer made with New Zealand hops.

After encouragement from friends, Sigman made the leap to professional brewing. Along with the usual regulatory and licensing hoops to jump through, he needed to push for local lawmakers to change zoning laws so that he could make beer in the cramped Plainville industrial park space. The reaction to his beer early on was very positive, and Sigman had to close the brewery down for a week just to keep up with demand. He originally wanted to hold on to his day job and figured that it would be a part-time business with a few customers with a one-barrel system, making about 45 gallons in a week. He evolved into a full-time brewer on a three-barrel system and makes about 150 to 200 gallons of beer a week. Sigman has expanded into what was once a florist shop next to his original brewery and has a tasting room that looks a lot like an art gallery. Not only does he celebrate the arts by displaying local painters' work, he also commissions some of the most beautiful twenty-two-ounce bottle labels in the business.

Sigman still loves to focus on recipe creation. Sometimes he builds a recipe around a single ingredient, like a variety of malted oatmeal (The Huntsman)

or the lavender from his garden (La Petit Abeile). "All of the creativity we're seeing comes from homebrewers getting into the professional market," Sigman said. "They don't teach that at brewing school."

THE BEER

Relic has an ever-changing array of beers, so it's advisable to check its website to see what's on tap at the tiny brewery. Sigman leans toward Belgian yeasts, which play a role in many of his offerings. Some say it denotes a spicy character, while others find the "Relic taste" to be bittersweet with dark fruit undertones. Sigman is also known to play with brettanomyces yeast, which can yield a "funky" flavor. Without a true flagship, Relic goes with more of a seasonal rotation.

Some of my favorites are in the malty end of the spectrum. These include THE HUNTSMAN, the oatmeal stout that's subtle and has a thick mouthfeel, and QUEEN ANNE'S REVENGE, a porter that has mocha notes. Relic's THRICE, a Belgian tripel, is a soupy, boozy delight.

On the lighter end, I enjoy CLOCKWORK, a Citra-hopped pale ale that's crisp and has a grapefruit pungency, as well as the WHITING STREET LAGER, which is golden and biscuit-like; it's one of the few that I liked cold.

Relic's beer is available in growler-fills, and many are sold in twenty-two-ounce bottles in liquor stores and on the premises. A few restaurants are catching on to Relic, and its biggest champion is J. Timothy's Taverne, which is also in Plainville. In 2014, Relic began contract-brewing some of its beer in twelve-ounce bottles at Thomas Hooker Brewing in Bloomfield. These include BIERE DE NOEL, a 7.8 percent ABV Christmas beer that features subtle clove and chocolate flavors.

Q&A

What are the advantages of being a nanobrewery, as opposed to one that is larger?

"Being so small lets us be incredibly nimble; we are essentially operating a pilot system. It gives us a lot of flexibility and creativity to brew lots of different styles and provides a lot of fun variety for consumers. It also lets

us do small-scale packaging runs, brewery-only releases and seasonal bottle releases very easily and at a fraction of the expense of larger breweries. For the same reasons, it's a lot easier for nanobreweries to try out new hops and ingredients and respond to market changes. In addition, due to the small nature and taproom experiences, I believe it's easier for small breweries to make lasting connections with customers, as people feel more invested in the business knowing and interacting with the owner and brewer."

–Mark Sigman, owner, Relic Brewing Company

Two Roads
Brewing Company

1700 Stratford Avenue, Stratford
(203) 335-2010
www.tworoadsbrewing.com
Founded in 2012

The Brewery

When Two Roads Brewing came onto the Connecticut scene, it wasn't just the new kid on the block—it was the *huge* new kid on the block. Connecticut had not seen anything like Two Roads Brewing before. Instead of a scrappy bunch of homebrewers hoping to make good, it was a multimillion-dollar partnership of men with big-brewery experience. Its plan was not merely to make its own beer either. Two Roads set itself up in a hulking one-hundred-year-old former manufacturing warehouse on a 6.6-acre site and invited breweries from throughout the country to brew there as well. By the end of 2014, there were thirteen contract breweries under its roof. "The strategy…gives us the luxury of contracts, to pay some bills and then, in a careful way, to grow the Two Roads brand," said Brad Hittle, co-owner and former marketing executive for Pabst Brewing. "Growing a brand in the craft world is no easy matter. A good chunk of the breweries are now national players. We didn't want to feel like we could not control our own destiny."

One of its most important moves was hiring Phil Markowski as head brewer. This Connecticut native and avid homebrewer played a role in the birth of modern craft brewing in the state. Markowski was working as an electrical engineer and started making his own beer in 1984. After entering homebrew competitions, he traveled throughout Europe, where he discovered the magic of Belgian beers. He took his talent and worked as a brewer for the New England Brewing Company, beginning when it was still based in Norwalk in the late 1980s. He worked sixty to eighty hours a week Monday through Saturday for NEBCO, and then on Sunday he would homebrew. Markowski's creativity as a brewer was not able to flourish on a larger scale until he co-owned Bier Haus, a brewpub in Merrimack, New Hampshire. "That's when I started to let loose in terms of being more creative and being able to brew to a wider palate of tastes," he said. "You could mix it up, unlike at a production brewery that only produces certain brands."

When that closed, Markowski moved on to the Southampton Publick House on Long Island, where he was given license to create even more experimental beers. "The first year, I produced a beer with local Chardonnay grapes and barrel-aged it at a time when very few people were," he said. "I

Two Roads Brewing Company co-owners Peter Doering, Clement Pellani, Phil Markowski and Brad Hittle. *Photo by the author.*

did a saison there in the mid-'90s, and I had to explain to more than one person who claimed to know about beer what that was." Markowski would go on to write a book about the category of beer that saisons fall under in 2004, *Farmhouse Ales* (Brewers Publications).

Now he heads up a brewery with a staff of twelve that work three shifts five days a week, creating more than fifteen thousand barrels of its own beer for Connecticut, Massachusetts, Rhode Island and metro New York. Going big in a large facility was always part of the plan, Markowski said, because that way the brewery would not need to expand. "I know there are people who don't like Two Roads because we're big," Markowski said. "But then it's not about the product. That can creep into people's opinions." Hittle said the perceptions that the company is run by corporate suits is just wrong. "We are a collection of decent, fun-loving human beings who embrace the beer community," he said.

If reading about Two Roads does not convince you how different it is from other breweries in the state, about two minutes into a visit will do the trick. It has a full, four-sided bar in a sprawling tasting room accented with round tables for socializing. Behind it is a colossal viewing window from which you can see the toil of bottling and brewing below. I had a chance to step into the nerve center of the whole operation to see the multi-screen, computerized command room where brewers can see the data on the beer they're brewing. It's like being at NASA, but with beer.

Hittle said that Two Roads' mission is to remedy an imbalance. "I feel like the mix is wrong," he said. "Only 20 percent of the beer drunk in Connecticut is made in Connecticut," he said. "We don't have our fair share. We're making sure Connecticut gets its fair share."

THE BEER

Two Roads produces a wide variety of year-round beers and an even more diverse and larger array of seasonals. Since we're talking about a head brewer with a love of farmhouse ales, I'd recommend the WORKER'S COMP SAISON, a low-alcohol refresher with hints of spice and what might be perceived as mango. To stay on the more sober spectrum, there's the surprisingly bold LIL' HEAVEN, a "session" India pale ale that packs a pleasant bitterness into only 4.8 percent ABV. Even milder is the OL'FACTORY PILS, which carries with it a pleasing aroma thanks to the dry-hopping process. For wheat beer

enthusiasts, there's the No Limits Hefeweizen, and to get your hop fill, you can try the Honeyspot Road White IPA (named for a nearby street, and it isn't sweet) or the Road 2 Ruin Double IPA, which features four American hop varieties but still won't ruin your palate. The one year-round beer that lives in a category all its own is the Unorthodox Russian Imperial Stout, a burnt-coffee/chocolate soup that warms you like a fur hat at 9.2 percent ABV.

There are several standouts from the large seasonal roster. They include the late-summer Via Cordis, an Abbey blonde ale that tickles the palate with a Belgian yeast strain, which makes it a great pairing for hard cheeses or turkey. If you like your ales fiercely aggressive, you'll like the Rye 95 spring release, which tears at the throat with a clovey yeast strain. In the summer, there's a complete departure with Road Jam, a wheat ale fermented with black and red raspberries that's dry and pairs well with picnics. Two Roads goes to rich extremes with Conntucky Lightnin', ale that's aged in bourbon barrels. For the truly debauched, however, there's Igor's Dream, a wintertime Russian imperial stout named for Stratford's helicopter legend Igor Sikorsky. At 11 percent ABV and aged in oak whiskey barrels, it's the stout to have when you're sitting down.

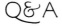

What's your advice to new brewers?

"If it's your passion, your dream, follow it. If you're doing it as a business, make sure you get help if you don't have business skills yourself. Passion alone isn't enough. On the brewing side, make sure you have the technical knowledge and skill to make beer commercially, that can be stable in the package and have a decent shelf life."

–Phil Markowski, head brewer, Two Roads Brewing Company

Broad Brook Brewing Company

2 North Road, East Windsor
(860) 623-1000
www.broadbroookbrewing.com
Founded in 2013

The Brewery

Broad Brook Brewing is a great example of avid homebrewers who wanted to take it to the next level. Co-owners Eric Mance and Joe Dealba have been friends for nearly thirty years and, over that time, have brewed a lot of beer and hard cider. Dealba met co-owner Tom Rossing through an angling club and bonded over one of Rossing's homebrews. Every Sunday for five years, they perfected their recipes, winning ribbons around the country at homebrew contests.

Rossing, who also works for himself as a contractor, said that the score sheets from judges gave them some direction for their recipes but that the group never veered from what tasted good. For years, they gave away beer to friends, getting feedback and winning over early fans. Mance, a computer security consultant business owner, took the lead on making the business plan, and over time, they created a brewery named after a local brook and neighborhood in East Windsor. When they opened, 190 people joined the brewery's mug club, most of them friends who'd already had a taste of what was to come.

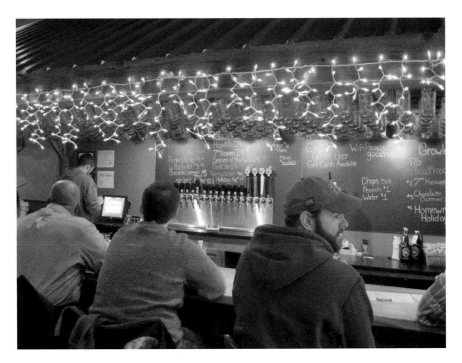

Broad Brook Brewing Company bar at Christmastime. *Photo by the author.*

Tucked inconspicuously into a strip mall in East Windsor, Broad Brook benefits from its proximity to Interstate 91 and is about fifteen miles south of the Massachusetts border. The taproom's bar is beautifully quirky. Built with reclaimed wood from an old tobacco barn, it covers the bar and its twelve taps. The ten small tables that spread on the other side of the room are large enough for a pair of sampling trays and some lunch, as the owners encourage bringing food in.

Behind the scenes, there's a fifteen-barrel system, and the brewery is producing more than eight hundred barrels per year in the five-thousand-square-foot space that used to be a warehouse. The brewery had to double its number of fermenters to ten in a little more than a year. After starting on draft in local restaurants, Broad Brook now also puts its Broad Brook Ale and Hopstillo in sixteen-ounce four-pack cans, and its beers are available in Connecticut and western Massachusetts.

"Working as a trio, you need to make sure that everyone is on the same page," Rossing said. "The way the brand is taking off, it's surreal."

The Beer

Instead of relying on a few flagships, Broad Brook has quickly bloomed to churn out fifteen beers. It has a variety of beers that span the styles, but most of them seem to have a sneaky hop zing and are fairly low in alcohol by volume. Among the brewery's "classic" beers, there's Broad Brook Ale. The copper-colored extra special bitter has a slight caramel finish to offset the mild hop bite, and all of the staff agree that it's the one beer they'd drink if they could only drink one. On the other end of the spectrum, the Porter's Porter is smooth and roasty, while the No B.S. Brown Ale is malty, with a subtle hop kick. The Chocolate Oatmeal Stout is a wonderful example of a dry stout. 7th Heaven IPA, which uses seven different varieties of hops, isn't the palate-wrecker that some American versions of India pale ales can be.

The brewery also has a "Tobacco Valley" series, which includes limited-edition beers that have a higher alcohol content. The Hopstillo IPA is more aggressive than 7th Heaven, with a bit of a citrus bomb that dries out stealthily. Broad Brook gets particularly off the charts with Pink Dragon Wit, which is actually pink from the dried hibiscus flowers added at the end of the boil. Overcarbonated on purpose, the wheat beer delivers a Champagne-like mouthfeel.

Q&A

What's the most surprising thing that's happened since you've opened the brewery?

"I guess the most surprising thing to us is the rate of expansion and the amount of people coming into the taproom. I guess that means we are doing something right. We didn't expect to buy six more fermenters in the first year of business or expand into canning as fast as we did, but the demand is there and we will follow."

—Eric Mance, co-owner, Broad Brook Brewing.

Firefly Hollow Brewing Company

139 Center Street, Bristol
(860) 845-8977
www.fireflyhollowbrewing.com
Founded in 2013

The Brewery

Grass-roots support helped propel Firefly Hollow Brewing from a gleam in the eye of homebrew shop employees to a cool place to hang out and enjoy well-crafted beer. To help pay for this dream, the co-owners turned to Kickstarter, an online fundraising site; by August 2012, they had raised over $10,000 more than their $30,000 goal. Along with earning money for fermenters, pumps and other brewhouse material, the campaign had a secondary impact: customer loyalty. By offering mugs, brewery tours and exclusive access to new beer, Firefly fueled the desires of hundreds of supporters.

It wasn't like the co-owners were inexperienced in beer. Rich Loomis co-owned Brew & Wine Hobby, a homebrew and winemaking supply store in East Hartford, and certainly knew his way around crafting beer. He partnered with Bill Collins, who would manage Firefly's accounts. One of the store's employees, Dana Bourque, emerged as Firefly's head brewer and face of the brewery. After two years studying nutritional science at the University of Connecticut, Bourque left to attend the American Brewers

Firefly Brewing Company head brewer Dana Bourque, just prior to the brewery's opening. *Photo by the author.*

Guild Apprenticeship program and worked with two breweries in the state: Thomas Hooker and Willimantic.

Like Bristol, the brewery and tasting room at Firefly are certainly rough around the edges. To get there, you have to spot the sign and then drive down a narrow driveway past a messy loading dock to your right that's attached to a grim-looking, four-story factory. Toward the end of the building is Firefly's brewhouse and taproom.

Upon entering, you're at the short end of the L-shaped bar that seats fifteen, facing the brewery's seven taps. The brewhouse is to the right, behind a door and giant windows. With a ten-barrel capacity, the equipment is of

the cobbled-together kind. The mash tun, a vessel where crushed malted grain is mixed with hot water, was actually formerly used as dairy equipment.

The brewery really took a lot of care in turning the space into an inviting lounge of sorts: twelve tables for two or four, communal table seating along some railings and cushy chairs for those who like to contemplate solo. The setting is all dark wood and gray cement columns, creating an industrial feel. There's a refrigerator with water and soda, which is perfect for designated drivers and for cleansing the palate. With occasional live music, it's the ideal place to chill out for an hour or so. Firefly doesn't serve its own food, but it invites food trucks to its parking lot.

The Beer

Firefly rotates taps regularly, so from week to week it's hard to predict what will be offered. One beer that's particularly popular is TOADSTOOL OAT STOUT, which benefits from flaked oat and boasts waves of smooth cocoa flavor. Coffee is the dominant taste in BROWN COAT ALE, an American brown ale that's bitter from the Chinook hops. My favorite dark beer from Firefly is its SECRET INGREDIENT STOUT; it's got a mellow mix of spices ("hints of clove, allspice and anise") and, of course, the mystery portion.

On the lighter end of the spectrum is the PENUMBRA CREAM ALE, which is so light it's almost clear. With a hint of New Zealand hops and made with pilsner malt, it's very refreshing. Firefly's WHITE BRICK SAISON is also made with pilsner malt, as well as Belgian candi sugar, and it has a tart finish that almost borders on a gentle sour beer.

Other beers kept on semi-regular rotation include the MOONRISE AMBER, RED LANTERN (an Irish red ale), LIZARD BREATH IPA, CONE FLAKES DOUBLE-IPA and RAMSHACKLE GOLDEN MILD.

Q&A

What is the best part of being the head brewer?

"The best part of being head brewer is the freedom to make my own decisions about production, recipe formulation, the beer lineup, etc. I only

answer to myself, which frees up a lot of mental capacity to focus on beer quality and uniqueness of product. In other words, I get to cultivate the creative aspect of being a brewer."

–Dana Bourque, head brewer, Firefly Hollow Brewing Company

SHEBEEN BREWING COMPANY

1 Wolcott Road, Wolcott
(203) 514-2336
www.shebeenbrewing.com
Founded in 2013

THE BREWERY

Ever heard of a brewery that has an Irish founder and a beer that references Italian desserts, another beer that combines German and Mexican influences and a canned offering of a West Coast version of an English ale? That's what you get with Shebeen Brewing. Co-owner Rich Visco was born in Derry in Northern Ireland but moved when he was a baby, hopping around with his military family to the States and eventually settling in Connecticut.

Inspired by Charlie Papazian's *The Complete Joy of Homebrewing*, Visco started homebrewing in the late 1980s, eventually building himself a three-tier rolling brewing rig. "My brewing got better at home as the equipment got better," he said. After some training from the American Brewers Guild in the mid-1990s, Visco focused on creating a business plan for a brewpub.

It wasn't until 2012, when he was approached by co-worker Pat Lacerra, that Visco meaningfully pursued creating a brewery. The partners brought on forty investors. They called the brewery Shebeen, an Irish word for an illegal drinking establishment, and leased space from Sullivan Brothers

Shebeen Brewing Company co-owner Rich Visco. *Photo by the author.*

Remodeling, which deals in furniture. Now they are up to four fermenters and two brite tanks, and they're joined by three employees and about twenty-five friends who volunteer at the fifteen-barrel brewhouse.

Visiting the brewery begins with the front room, where there's a mural depicting a whimsical Irish street scene. You can hang out there at the small tables or meander into the "visitors' center," which features long, wide, communal wooden tables. On warm enough days, you can also hang out on the brewery's deck.

THE BEER

Shebeen makes a lot of beers, but only a few make it into bottles or cans. Its BLACK HOP IPA is one that was distributed in cans first; it's a hoppy ale that is indeed black in appearance. What's appealing about this one is how the beer matures over time in a pint glass; it's at first bitter, but the caramel sweetness balances that out over time.

The beer Shebeen is best known for, however, is its CANNOLI BEER. It's an American pale ale spiced with specialty grains from France along with bourbon-soaked vanilla beans, cinnamon and nutmeg. What makes it a "cannoli" is that it's topped and rimmed with powdered sugar, with a healthy portion of shaved dark chocolate on top of a rocky white head. "Our Cannoli Beer was just a challenge, but it struck a chord with females and even the older, non-traditional craft beer drinkers," Visco said.

Shebeen has a variety of ales. Its CONCORD GRAPE SAISON certainly sticks out; it's a viscous, high-alcohol, wine-like ale. From PINEAPPLE WHEAT and an IDAHO IPA (made with hops and malt from the Gem State, along with Betty Crocker instant potatoes) to its JAVA PIG STOUT and CUCUMBER WASABI beer, you could leave the brewery enlightened, confused or both.

Q&A

What drives you to experiment with non-traditional ingredients?

"I don't think our beers use non-traditional ingredients. In fact, they are very traditional in the sense that we use ingredients around us. For example, our Concord Grape Saison is what people would have made two hundred years ago. I used grapes that grew in my backyard and flavored a traditional dark farmhouse beer. Beers were made with what grows around you…We may use spices here and there, but it's no different than when people were adding hops or even spruce in colonial times to flavor a beer. We do fight with trying to please the traditionalists, but you can't. You just have to make beers that you feel good about and find beers that people take to."

–Rich Visco, owner, Shebeen Brewing Company

Top Shelf
Brewing Company

422 North Main Street, Manchester
(860) 680-4105
www.topshelfbrewery.com
Founded in 2013*

The Brewery

When buddies with homebrewing experience but professional lives in unrelated fields decide to follow their passion and start their own brewery, the result is far from guaranteed. For Michael Boney and T.J. Lavery, who grew up together in suburban Connecticut, eight years of tinkering and getting compliments on their creations led to Top Shelf Brewing, originally a small, three-barrel operation in a rough-looking two-thousand-square-foot space in a building from the 1890s. They were one of eighteen in a commercial complex in Manchester that was once famous for a woolen mill. However, it looked like it had been smashed by an invading army seventy years ago and never repaired. Using money saved up from a decade in the rental car and insurance business, the partners used their own money to build up the business. "When we first decided to do this thing, we started the company on a handshake and with friendship and trust," said Boney.

Top Shelf Brewing Company logo. *Courtesy of Top Shelf Brewing.*

They decided to brew beer that hopped from American to Belgian to Irish traditions, and after two years, Top Shelf was ready to expand. According to Boney, the brewery will be moving to a ten-barrel brewhouse with a bar and taproom in a 2,500-square-foot space that includes a mezzanine overlooking the brewery. Top Shelf plans to distribute in cans as well. "We were small and brewing to capacity, and our beer was well received," Boney said. "We just want to take it to a new level and have better accessibility."

The Beer

Top Shelf offers flagship beers, including two IPAs. Around the Clock IPA is the rare "session" variety, meaning that its alcohol by volume percentage is a low 4.8. It's made with five malts and Cascade, Chinook and Mosaic hops. Marathon IPA is meant to be more bitter. On the other end of the spectrum, Anytime Stout is a milk stout with only medium bitterness, made with chocolate malt.

The brewery releases monthly "MVP" series beers in bottles that are higher alcohol. Be on the lookout for beers like the Red Double IPA, Oatmeal Cookie Brown Ale and Cherry Stout.

Q&A

What was the most unexpected thing that's happened since you've started Top Shelf?

"I'd say it was the success of the limited-release beers, which we call our MVP series. We started out with 120-bottle releases. We figured it would appeal to special people who like high-alcohol beers. Those first ones would sell out in three weekends. Then we made Oatmeal Cookie Brown, and we sold 120 of those in ten hours."

–Michael Boney, co-owner, Top Shelf Brewing Company

DuVig Brewing Company

59 School Ground Road, Branford
(203) 208-2213
www.duvig.com
Founded in 2014

The Brewery

The story behind how two couples became DuVig Brewing is straight out of a film script. It was the winter of 2013, and a blizzard had just dumped a ton of snow on the region and knocked out power along Connecticut's south, where it borders the Long Island Sound. Darcy and Scott Dugas had power; Kim and Dan Vigliotti didn't. So, what better way to ride out the storm together than over some homebrew? Both couples had plenty in stock, and while the bottles popped open, so did a tentative plan to start a brewery.

As Kim Vigliotti tells it, it's the men who had the brewing experience and the women who more or less run the business side. A former high school assistant principal, Kim put her years of organization to use, and it took only eighteen months to get DuVig up and running with a small, three-barrel system in a 1,500-square-foot space. "We kept it very quiet," she said. "We didn't want a lot of buzz around it. None of us had ever been in the beer industry outside of homebrewing. So every step we were learning as we were going."

Scott and Darcy Dugas of DuVig Brewing Company in Branford. *Photo by the author.*

The focus from the start was on "session" beers, the British term for low alcohol. Being able to have a few beers that are about 5 percent ABV meant more to the couples than making highly hopped or boldly malty beers that, frankly, are very popular. But squeezing flavor out of low-alcohol beers is a welcome accomplishment, and one that drinkers appreciate.

Their brewery, which is part of an industrial park, is quite small. The tasting room is inviting, but with more than ten people it might seem a bit crowded. There's a friendliness about the couples that's undeniable. It feels like you're in an extension of their homes when you stop by for a growler refill. DuVig is available in restaurants in southern Connecticut, including New Haven, Trumbull and Hamden. It hopes to bottle in the near future.

The Beer

DuVig offers three styles on draft, and while it would be easy to pigeonhole it as the "session" brewery, clearly it has more to offer than lower-alcohol beers. The Brown Ale brings out a lot of chocolate from the malts and sits on the tongue with a pleasant viscosity that allows you to experience the gentle hops in the background. At 4.8 percent ABV, it's the least likely to impair you. The Cream Ale (5.3 percent) could pass for a lager, while the Pale Ale (5.1 percent) is the one that gives you the mild caress of citrus from the hops.

Q&A

What are the advantages and disadvantages of working with your spouse?

"Well, that's a loaded question. The advantages: we're always with each other. The disadvantages: we're always with each other. I mean, we love being together, but sometimes it drives us to drink. But in all seriousness, owning a business together is exciting, challenging and fun and something we are building together. There's a sort of romance that comes with establishing our brand and growing our business together as a husband/wife team. At the same time, there's no time away from work. It can consume personal life if we let it because while work is work, work is so closely tied to our personal lives and livelihood. And that can become a stressor."

–Kim Vigliotti, co-owner, Duvig Brewing Company

OEC Brewing Company

7 Fox Hollow Road, Oxford
(203) 295-2831
www.oecbrewing.com
Founded in 2014

The Brewery

If the Connecticut breweries were a grammar school class, OEC would be the new kid who doesn't fit in. He wears clothing that isn't trendy, he says things in a strange way and he couldn't care less if he sat at the popular table or not. OEC stands for "Ordinem Ecentrici Coctores," which is grammatically incorrect Latin for "Order of Eccentric Boilers." The name is a spoof on the "secret societies of yesteryear," which kind of gives you a hint that owner Ben Neidart has a quirky approach to brewing. Not many American breweries would offer a sour beer right out of the gate, for example. And most would not go to the extent that he does to create beer in an "old-world way" that reflects the traditions of northern Europe.

Neidart, who was thirty-two when he started OEC, was born in Stuttgart, Germany, but was brought up on the East Coast since the age of ten. After studying computer science at Northwestern University in Evanston, Illinois, Neidart worked for a big advertising company in New York City. Neidart branched out into freelance web design, which led to

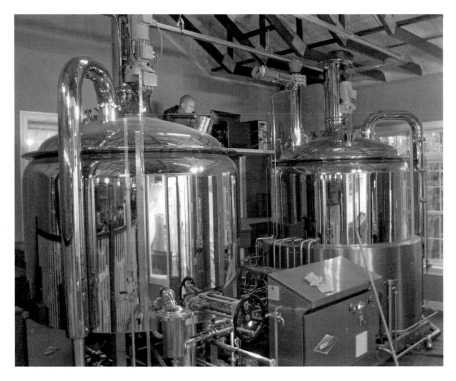

OEC Brewing Company co-owner Ben Neidart at his brewhouse. *Photo by the author.*

a stint working for his father, who owns B. United International Inc., an alcoholic beverage importer. Once the idea of producing his own beer got a hold on him, Neidart assisted at a few European breweries and took brewing classes. He partnered with co-brewer Tony Pellino and had a brewery built right next to B. United. Tucked into an industrial park, OEC benefits from B. United's barreling space, but Neidart stressed that he's independent of his father's company.

The brewhouse features a twelve-barrel system in an impressive arrangement that allows the brewer to stand high up on a platform to survey his tanks, as well as the 2,500-square-foot space. What sets it apart from most breweries is that it employs a coolship, which is a shallow, 6- by 15-foot copper vessel designed to cool the hot beer before it's fermented. OEC takes advantage of the method to infuse flavors and invite naturally occurring bacteria. OEC also employs a Baudelot, an open counter-flow cooler used in place of a standard plate heat exchanger that collects the unfermented beer in a trough at the top and then cascades it down the outside while cold water runs through pipes on the inside. The brewery also smokes some

of its malt and uses a traditional copper-bottle kettle. There's even a small garden next to the brewery, where OEC grows its own raspberries, lemons and Marechal Foch grape vines, which are added to beers aging in wooden barrels to induce another round of fermentation.

Neidhart's German background and American upbringing are apparent in his approach. With his stereotypically precise German side, he uses his knowledge of chemistry in the brewery's small laboratory, where he tailors the composition of yeast for specific beers. With his free-spirited American side, Neidhart's all about experimenting with ingredients and venturing outside the prescribed style. "There are a lot of unknowns in brewing, like how flavors are created and why the yeast does what it does," he said. "There's still a lot of mysticism."

THE BEER

Connecticut breweries aren't known for making sour beers. So when OEC opened with its TEMPUS SOUR BLENDED SAISON and EXILIS, a sour wheat beer, people took notice. The Tempus is brewed with spices and mixes ale that's been aged in oak barrels with "young" ale that has not. The Exilis is a delicate 3.8 percent Berlinerweiss that has a bright tartness.

There are several other OEC offerings, which you can try at one of its communal tasting tables. AMARA is a Grodziskie, a smoked beer from the Polish tradition; it's made with OEC's smoked wheat malt and is hopped with a combination of Styrian Goldings (a European hop) and Sterling, a modern variety that's known for its bitterness. PHANTASMA is a German porter that incorporates wheat, oats, molasses and licorice root. For kicks, OEC created a sour version of the Phastasma and a "sweet" version that is blended with wheat ale. OEC also makes NOVO, a blended dry-hopped saison.

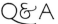

Q&A

What can new Americans brewers learn from the European masters of old?

"I think quite a bit. Brewing is thousands of years old, and brewmasters have learned their craft over many centuries. It would be foolish to ignore

the techniques and methods they developed during these years. Actually, a number of things we consider 'new innovations' in beer are simply techniques brought back from the past, such as dry hopping, first-wort hopping, barrel-aging and souring beers. We very much enjoy researching and using these old techniques, particularly old mashing techniques such as decoctions and turbid mashes. Rather than just creating as many fermentable sugars as possible, these techniques create more complex sugars that lend body and depth to beers."

–Ben Neidart, owner and brewer, OEC Brewing Company

Overshores Brewing Company

250 Bradley Street, East Haven
(203) 909-6224
www.overshores.com
Founded in 2014

The Brewery

In the recent wave of new breweries in the state, owners have had to make a choice: make a wide variety of beers or specialize. Christian Amport of Overshores made a decision to specialize in Belgian-style beers, a gamble that's paid off for Brewery Ommegang in New York and Allagash Brewing Company in Maine. The question is: will it take off in Connecticut? There are certainly more restrictive niches than the Belgian-style, which is revered for its complex yeast-inspired tastes that dabble in hints of spice, clove and plum.

The Wilton native Amport attended business school in Boston and worked for Starbucks in Seattle, and that exposure to craft beer in two of the country's craftiest of cities made its impact. Amport grew to love Belgian beer while homebrewing and was a bit surprised upon returning to his home state to see that Connecticut had not kept up with the surging rate of craft breweries in the country. He was determined to use his MBA to help right this wrong, and though only in his mid-thirties, he put himself in charge of his own brewery.

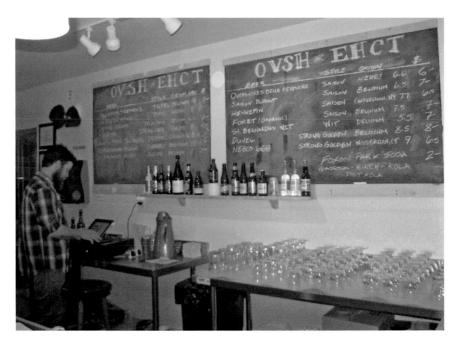

Overshores Brewing Company tasting room. *Photo by the author.*

To make the dream a reality, he brought on the only other member of the Overshores crew: head brewer Brian Cox. The former lead production brewer at Bluegrass Brewing Company in Louisville, Kentucky, was not very experienced in making Belgian-style ales before teaming up with Overshores but was ready for any learning curve. "The biggest challenge is the yeast management," Cox said. He uses a commercially available yeast but wants to experiment with the versatile ingredient.

Amport decided on an eleven-thousand-square-foot industrial space in suburban East Haven, only ten minutes from downtown New Haven. He refurbished the brewery and put in a bottle room, which has a small L-shaped bar and a few tables where about thirty-five people could sample comfortably. There, you can try Overshores beer, as well as other guest bottles like Duvel, a Trappist ale from Belgium's Duvel Moortgat Brewery, and Hennepin, a saison made by Brewery Ommegang of Cooperstown, New York.

Amport believes that Overshores will benefit from shipping its products, many of which will mature well in the bottle. He's designed some beers to age: the Tripel Brün and Belgique du Noire are both high-alcohol beers in corked, 375ml and 750ml bottles, and they can be cellared for years and will get more interesting in time, Amport said.

THE BEER

Overshores' beers may all fall under the category of "Belgian-style," but that does not mean they taste the same. The first beer it put out, BELLE FERMIERE, is a 6.6 percent ABV saison that's orange, light on the tongue and a bit tangy. It's not a strict interpretation of a Belgian saison, which can mean it has earthy, spicy or even sour flavors based on unpredictable fermentation. This is a hoppier, "Americanized" version.

Two other very different offerings are related: the SIMPEL and the TRIPEL BRUN. In the Belgian tradition, Overshores makes two beers from the same mash, which is an early stage in brewing where the crushed grains meet hot water. The first runnings come out thickest and have the most concentrated sugars; from this, Overshores made the Tripel, a 9.5 percent ABV Belgian strong dark ale. Water from a second running creates a beer with much less sugar, and you end up with a dry, crisp beer like the Simpel, which is only 4 percent ABV "table beer." It's gentle but has enough citrus notes from the hops to give it complexity.

Overshores' BLANC DE BLANCHE is a 6.4 ABV Belgian-style wheat beer, but for true maximum boldness, try the BELGIQUE DU NOIRE, a Belgian-style imperial stout that clocks in at 9.5 percent ABV.

Q&A

What are the biggest challenges when starting up a brewery?

"I think that the challenge I've found is the hours. As an entrepreneur in any small business, you wear a lot of hats, and responsibilities fall on the owner. But with a brewery, you're open on the weekends, festivals are on the weekends and then events are in the evenings. On the other hand, the business hours are when your suppliers and retailers and wholesalers work office hours. What you find eventually is that you are working every day. I got a call last night at 9:00 p.m. from a manager of a musician to talk about booking her in our bar in a few weeks. It's like being a doctor—you have to be on call. Starting a business of any kind is a challenge to maintain a work-life balance. It's not unique to the brewery business."

–Christian Amport, owner, Overshores Brewing Company

STUBBORN BEAUTY BREWING COMPANY

180 Johnson Street, Middletown
www.stubbornbeauty.com
Founded in 2014

THE BREWERY

Old, weathered factories that dot the Connecticut landscape inspire two reactions: revulsion or fascination. They used to be how the state made its name as a manufacturing center. Over the decades that these former mills, warehouses and labor centers have gone to seed, however, there have been efforts to revitalize them as housing. They've also found new life as brewhouses. Even if they're scruffy or remote, they give the breweries automatic character and—best of all—a blank canvas. The two homebrewers with a dream and a business plan behind Stubborn Beauty have their own corner of a revitalized warehouse in Middletown that's a little tough to find. There, in a 2,700-square-foot space in a remodeled bicycle factory, they've set up a 3.5-barrel system that leaves room for growth.

Shane Lentini and Andrew Daigle started brewing on their own with a turkey fryer in 2009. After positive feedback and a few competitions under their belts, they decided right away to form a limited liability company. It took five years, but they were able to bankroll the operation themselves and signed a lease in April 2012, in a building owned by the City of Middletown.

Stubborn Beauty Brewing Company, from behind the bar. *Photo by Stacey Blanchard.*

The men have kept their day jobs—Lentini as an information technology engineer and Daigle as a medical equipment technician—but have plans to make brewing their full-time gig.

The brewery is tucked away next to railroad tracks in a long brick building. You'll need to drive past the coffee roaster and gym before you see the bright-red rose logo. It's hung beneath broken-out, boarded-up windows. Inside, you'll find a small but tidy tasting room with four narrow, stainless steel communal tables and clay-red walls. There are industrial accents of silver all around, including the copper tanks on the far wall. If you visit, you can sample from eight taps, but be prepared to pay in cash, even just to sample. They're also on tap in more than forty locations in the state.

THE BEER

Stubborn Beauty has a solid selection and a rotation that changes regularly. HOW RYE I AM is out of this world; this saison includes a lot of rye malt and yields a funky aroma, smooth mouthfeel and a gentle bitterness. NUMMY NUMMY, an 8.1 percent ABV double IPA, is particularly popular, with its

bold grapefruit flavor. For a power punch of dry malt flavor, try 8 percent PORTER JUSTICE IMPERIAL.

Other winners include NIGHT ON THE SUN, an orange "harvest pale ale" that has a delicate, piney aroma and finish, as well as the AUSTRALOPITHECUS, an easy-drinking, Belgian-style pale ale made with Australian hops. If you're a wheat beer and *Police Academy* movie enthusiast, I recommend the KOMMANDANT LASSARD dunkelweizen, which is sweet and effervescent.

Q&A

What sets your brewery apart from others?

"We don't want to make any other kind of beer another brewery makes. We don't want to make a Heady Topper; Alchemist [a brewery in Vermont] already does that very well…What sets us apart is that we have a little ability to put something on paper and see how it will taste. We've tested the limits, like putting in over 10 percent crystal malt, just to see what happens."

–Shane Lentini, co-owner and brewer,
Stubborn Beauty Brewing Company

Black Hog Brewing Company

115 Hurley Road, Building 9A, Oxford
(203) 262-6075
www.blackhogbrewing.com
Founded in 2014

The Brewery

Black Hog is the merger of the truly fermented. Take a couple of brothers who have established themselves as restaurateurs who relish boutique cheeses. Barrel them together with a brewer who has made his mark at one of New Hampshire's premier breweries. Provide them with the equipment of a recently defunct brewery in a spacious-enough area, and you've got promise. The brothers are Tom and Jason Sobocinski, who already run a cheese shop called Caseus and a bar called Ordinary, both in New Haven. When they were coming up with the idea to start a brewery, they turned to the husband of a friend of theirs; brewer Tyler Jones had experience working at Portsmouth Brewing Company in New Hampshire, and the offer came at the perfect time. With a desire to be close to his wife's family, Jones made the move, and Black Hog was born as a collective with several investors.

The crew decided to take over where another brewery left off. Cavalry Brewing Company had been making English-style ales at the Oxford

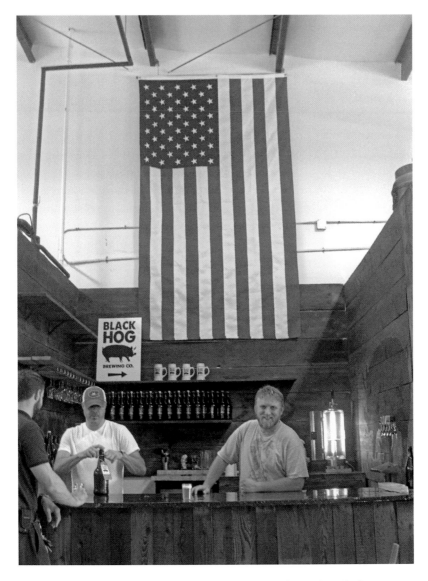

Black Hog Brewing Company head brewer Tyler Jones, *right*, and marketing manager Chris Charest, behind the bar. *Photo by the author.*

industrial park space for several years before folding. Luckily for Black Hog, it was willing to sell its equipment and happened to have an assistant brewer eager to show Jones how he used it. Justin Benvenuto now brews alongside Jones, helping him harness the potential of the fifteen-barrel brewhouse. "The art and craft of making the good beer is mastering the

mash tun and getting what you want out of your grains based on the constraints of your equipment," Jones said. Since it started with its four flagship beers, Black Hog has been exploring new directions. Among its fermenters is a "disco tank," for its "funky" beers. These would be the ones carefully infected with brettanomyces and will eventually end up as bottle-conditioned offerings.

Jones started brewing in 2002 after finding a homebrew kit left behind at a house he was staying at while attending the University of New Hampshire. The chemical engineering major took to it immediately and decided—after a short stint in sales—to attend University of California–Davis's master brewer program, which he completed in six months. Jones made his way back east, and after working at Mercury Brewing in Massachusetts, he persuaded head brewer Tod Mott to give him a job at Portsmouth Brewing. "He was a true artist," said Jones of the man credited with creating the world-renowned imperial stout Kate the Great. "He taught me so much that you just can't learn in a school. It's in the subtleties."

While not in the most picturesque of locations, Black Hog has a welcoming feel once you're inside. It's got old-school arcade games and a little bar area for playing games like Jenga.

THE BEER

Black Hog produces a variety of year-round and seasonal beers. Its GINGA' NINJA (red IPA with fresh ginger) is one that actually stems from Jones's time at Portsmouth Brewing. Delicate and light, this one is a real treat, especially during the warm months. Its EASY RYE' DA is a lower-alcohol India pale ale made with rye, and it surprises you with the amount of flavor that can come from a beer not made with as much malt base as most. My personal favorite is the GRANOLA BROWN ALE, which incorporates flaked and malted oats and comes out like bittersweet chocolate.

Not afraid of fruit, Jones crafts S.W.A.G. (SUMMER WHEAT ALE WITH GRAPEFRUIT), which also has a hint of sage in it, and STRAWBERRY GOSE, a gentle German-style beer that uses pink Himalayan salt and one hundred pounds of fresh strawberries.

Q&A

How do you think you stand apart from other breweries in the state?

"There are some quality issues [at other breweries]. The quality of the beer needs to be number one. Then you work back from there. I'm honestly foreseeing a lot of two- to four-barrel systems for sale...in three years. They're realizing that they aren't making quality beers and paying the bills anymore. A lot are doing it right on a small scale...My goal is to be available everywhere in Connecticut. I think our beer is delicious; it's unique and easy to drink. There aren't a lot of people doing that. You can have a unique beer that you don't want a second one of. Or you have an easy drinking beer that doesn't have the consistent quality."

<div align="right">–Tyler Jones, head brewer, Black Hog Brewing Company</div>

BLACK POND
BREWING COMPANY

21 Furnace Street, Danielson
(860) 207-5295
www.blackpondbrews.com
Founded in 2014

THE BREWERY

One of the few breweries in Connecticut's rural northeast, also known as the "Quiet Corner," Black Pond Brewing is a newcomer that's starting very small. It has set up shop as part of a building it shares with Danielson Adventure Sports, a bicycle store. In just five hundred square feet, Black Pond is making four diverse beers, along with randomly available one-offs. On its 1.5-half barrel system, it creates batches that range from fifteen to forty-five gallons.

Co-owners and co-brewers Cory Smith and Mike Teed grew up together in the area and named the brewery after the pond in their hometown of Woodstock, Connecticut. It was soon after graduating from college—where neither studied anything even close to being related to beer—that they decided to throw themselves into homebrewing. Starting with an extract kit in about 2009, Smith and Teed brewed a variety of clone beer and original recipes before they created a few they thought would be worth buying. "The biggest challenge when we went to brewing professionally was scaling up and using our bigger system," Smith said.

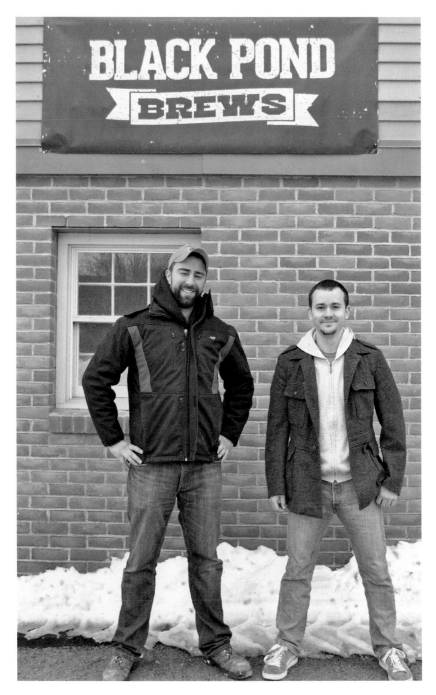

Black Pond Brewing Company co-owners Cory Smith and Mike Teed. *Photo by Stacey Blanchard.*

Leasing space at the bike shop made sense: the owner was already holding beer and wine tastings there and even tried carrying homebrew equipment, Smith said. A move that, in retrospect, turned out to be a smart one was creating the Quiet Corner Homebrew Club, which alerted them to a community of beer lovers waiting for someone to create a brewery in the relatively remote area for a small state. When it came time to actually build the brewhouse, Smith and Teed were able to turn to the members to help build their walk-in cooler and other pieces to the brewery puzzle. "From the time we started brewing, people have told us that it would be great to have something in our area," Smith said. "Being removed in that sense is an advantage for us." With aid and advice from the brewers at Beer'd Brewing in Stonington and Willimantic Brewing, these east siders have helpful company.

The Beer

Black Pond produces four beers regularly. It named its Israel Putnam Brown Ale after the Revolutionary War hero who also ran a tavern in nearby Brooklyn, Connecticut. The brewers use Cluster hops as an homage to the early days of the colony, since it was the first hop strain indigenous to colonial America. Its Razor Blades IPA is quite a different beer; unlike its mellow, malty counterpart, this ale features nine different hops, including Green Bullet hops from New Zealand, as well as the domestic Citra. Black Pond also makes a lager known as Connecticut Uncommon. The brewers use rye and the Northern Brewer hop to balance the beer with some bread-like qualities. For an exciting twist, Black Pond makes Machu Picchu Jalapeño Saison, which is a "style that can scare people away," Smith said. Made with fresh jalapeños, this beer also features wheat and corn to provide sweet balance. Saison yeast is added to accentuate peppery notes.

Q&A

Why are cyclists drawn to beer?

"The biking community is always planning their lives together and is very socially active. When they are done riding, they want to work hard and talk

about their ride…They ride every Tuesday night, and we share beer and talk about the ride. Inevitably, one person had something break or gets a flat tire and has to come back early. So, drinking early is that silver lining to breaking down."

—Cory Smith, co-owner, Black Pond Brewing

Powder Hollow Brewery

504 Hazard Avenue, Enfield
(860) 205-0942
www.powderhollowbrewery.com
Founded in 2014

The Brewery

Way up north in the central part of the state, you'll find Powder Hollow Brewery, owned and operated by Mike McManus, who started his venture at the tender age of twenty-four. He started homebrewing at twenty when he was a student at Vermont Technical College, where he studied construction management. "I'm lucky that I got a bachelor's degree, and a majority is just business management, how to manage time and situations," McManus said. "Although I'm not building anything on a daily basis, it did help me out in managing my money and crew." McManus decided to return to his hometown to create his brewery, named for a historic area that itself refers to a gunpowder manufacturing business that once operated there.

With its brewpub license, Powder Hollow brews its own beers on site and can sell samples, pints and growlers to go. With his custom-built 2.5-barrel brewhouse, McManus brews about twice a day, every day creating a different recipe. "Our goal is to once a week brew something we have never done before," McManus said. "I like to do that with homebrewing. I get

Powder Hollow Brewery. *Courtesy of Powder Hollow Brewery.*

comfortable with a general style, then I add this or that." The brewery is in a 2,400-square-foot building from 1929 that used to store hay and serve as a textile mill and even as a facility for toy testing. McManus's 2.5-barrel toy gets plenty of testing, and he's created a fourteen-tap bar to spread the wealth. The brewery can fit up to eighty people, and being only two miles from Interstate 91, it's pretty conveniently placed.

"Breweries don't come with instructions," McManus said. "Every day is a puzzle to be worked out. Every day is a new adventure. It's just a big learning process."

THE BEER

Powder Hollow has plans to rapidly change its selection, so you'll probably need to check in advance what's available. It's been known to keep an OATMEAL STOUT on a dedicated nitrogen line and to serve a HOPPY HOLLOW IPA, which uses four different varieties of hops.

Q&A

What kind of reaction have you received?

"Everyone around here offers positive feedback and is willing to try everything. Even the big IPAs and strange beers. We almost want to do what the brewer at Dogfish Head [Brewing in Delaware] is trying. I believe my customers around here are supportive of this system. We're going small, everything made by hand. I think that's what people appreciate."
—Mike McManus, owner and head brewer, Powder Hollow Brewery

OTHER CONNECTICUT BEERS

STONY CREEK BREWING COMPANY

5 Indian Neck Avenue, Branford
(203) 684-3150
www.stonycreekbeer.com
Founded in 2011

THE BREWERY

The owners of Stony Creek began with brewing their beer at Thomas Hooker Brewing in Bloomfield, and as this book was going to press, they were creating a thirty-thousand-square-foot space on the banks of the Branford River near New Haven. It was the culminating step in the reinvention of the brewery. With the hiring of a head brewer in 2014, there was an overhaul of the brewery's offerings, which until then was limited to a lager and three very similar versions of an India pale ale. It will be the second-largest brewery in Connecticut, after Two Roads Brewing in Stratford.

Construction of the brewery began in 2014 on formerly contaminated land in the Indian Neck part of town, although the brewery is named for another one of Branford's neighborhoods. The brewery is slated to be built in a flood zone, so it's raised off the ground more than 6 feet. There are plans on the books for two outdoor decks and even 150 feet of dock space for sail-up visitors.

Stony Creek Brewing Company tanks. *Courtesy of Stony Creek Brewing.*

Brewer Andy Schwartz said he's bringing his West Coast and East Coast experiences to make what he's calling "aggressively balanced" beer. A brewer for twenty years, Schwartz started in Colorado with Overland Stage Shop Brewery after studying at Siebel Institute in Chicago. He moved to San Diego, where he brewed with Oggi's Pizza and Brewing Company for eight years, and during that time, he managed Oggi's Left Coast Brewing Company. In 2007, he moved to Portsmouth, New Hampshire, to brew for the Craft Brew Alliance, which makes Redhook, Widmer Brothers and Kona beers.

He said he sees his strength as being able to create hop-forward beers that are still clean. His laboratory is a thirty-barrel brewhouse that he got to watch being built from the ground up. The brewery is owned and run by the Crowley family. Ed Crowley Jr. serves as president, and his father is co-owner.

THE BEER

Stony Creek has an array of beer styles it plans to unleash once it's up and running, including an amber Vienna lager, a session IPA, an American IPA and a double IPA. Schwartz said that there will be seasonal and limited-release beers offered as well.

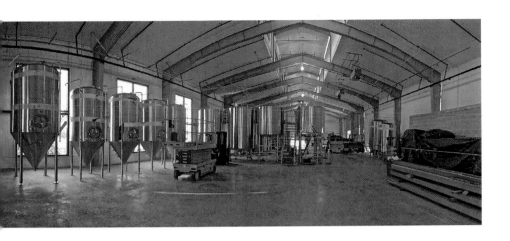

Q&A

How would you describe the current state of beer in Connecticut?

"We're sandwiched between some great states: Vermont, New Hampshire, Massachusetts and New York. They have more advanced markets, but this state is now experiencing some of what's going on in the surrounding states…We think that the breweries in the area are going to keep people from driving through. We're giving them reasons to stop now."

—Andy Schwartz, head brewer, Stony Creek Brewing Company

Charter Oak Brewing Company

Corporate office based in New Canaan, brewed at Paper City Brewery,
Holyoke, Massachusetts
www.charteroakbrewing.com
Founded in 2012

The Brewery

Charter Oak Brewing Company is the product of P. Scott Vallely, who spent a career in the paper distribution business before turning to beer. After selling his fifth and last company, Paper.com, Vallely took his thirty years of homebrewing experience and, on the advice of his wife and after methodic

Charter Oak Brewing Company logo. *Courtesy of Charter Oak Brewing.*

research, decided to go pro. "I saw that the paper industry was shrinking, and it wasn't fun anymore," he said.

Charter Oak is named for a real white oak tree in Hartford where, legend has it, a smart colonialist hid a Royal Charter signed by Charles II that basically permitted Connecticut self-governance. In 1687, more than twenty years after the charter was signed, King James II sent armed troops to seize the document and revoke it. By hiding it in what became the "Charter Oak," Captain Joseph Wadsworth is credited with an act of courage.

Branding wasn't enough, however. Vallely needed to make the kind of beer he'd made in his twelve-gallon system at home. Instead of investing in a brewery, he went out of state to use Paper City Brewing Company in Holyoke, Massachusetts. The brewery, which also makes beer for several other breweries, does not just brew Charter Oak by remote control, Vallely said. He takes part in the brewing once or twice a week, putting in ten-hour brew days with the twenty-six-barrel system, from milling the grain with Paper City's staff to pitching the yeast and sanitizing the tanks.

The end game was always to build his own brewery, however, and Vallely said that he will open a thirty-barrel brewhouse in South Norwalk. Vallely said that he approached owning a brewery the way he did his paper distribution companies, with plenty of research and planning. "I think the demand for craft beer in Connecticut will continue to increase," he said.

The Beer

Charter Oak makes beers with names that reflect the Charter Oak legend. The 1687 Brown Ale is an American version of the English style; it has a light bitterness you might not get in the true British style, but the malt does come through. In a more piney direction, thanks to Chinook hops, there's Wadsworth's India Pale Ale, which has five types of barley to balance out the bitter. Vallely calls his Royal Charter Pale Ale his "unsung hero"—a sessionable, dry beer that doesn't overcrowd food.

Charter also puts out limited and seasonal releases, including a porter and a kölsch-style ale. One I tried that impressed me a lot was the Lights Out Stout. It's big at 9.1 percent ABV, and as you drink it, you slowly taste a story that begins with toffee, evolves into cocoa, take a right turn at plum and slides quietly into caramel.

Q&A

What advice do you have for people who want to start a brewery in Connecticut?

"First of all, be sure that you have enough cash. Then, before you even put a spade in the soil, get your contracts with a hops dealer because hops can be difficult to come by. Finally, be sure your wife has good benefits."

–P. Scott Vallely, owner and head brewer,
Charter Oak Brewing Company

Pies & Pints

25 Leavenworth Street, Waterbury
(203) 573-1743
www.piesandpints.biz
Founded in 2014

When the owners of a Southbury pizza restaurant with a decent beer selection decided to open a second restaurant in nearby Waterbury that would feature its own beer, it was a rather gutsy move. Waterbury is not known as a thriving metropolis, and there had not been a working

brewery in the city for years. However, Theo Anastasiadis and Christos Gogas purchased the former Drescher's Restaurant, which closed unexpectedly in 2013.

The owners' original plan was to brew beer on the premises, but there have been setbacks. They enlisted the help of journeyman brewer John Watson, who had been earning medals as a homebrewer since the mid-1990s. They even went so far as to put brewhouse equipment in a dining room, but after a breakdown in negotiations, Watson and Pies & Pints went their separate ways just months after Watson started brewing beer for the restaurant at the former Cavalry Brewing Company in Oxford and, later, Shebeen Brewing in Wolcott.

Anastasiadis said that he will continue to work with the staff at Shebeen himself and continue to make beers. He regularly has Pies & Pints beer on two of its twenty-eight taps. Situated not far from the city's green, the pub has a small bar area with high booth seating and comfortable separate dining rooms. The restaurant hosts regular beer dinners.

THE BEERS

It's hard to say which beers will be available at Pies & Pints. Its current beers are HOPPY BROWN ALE and a SESSION IPA. Anastasiadis said that he hopes to have a three-barrel brewhouse up and running some day.

Q&A

What are your plans for the future?

"We want to be more of a brewpub than a brewery…It's a priority of mine, but we will still brew at Shebeen. We have so many people who want to brew with us."

–Theo Anastasiadis, co-owner, Pies & Pints

BREWERIES ON THE HORIZON

Depending on when you read this book, any number of these breweries described could be thriving or a pleasant memory. As of publication, however, Connecticut microbrewery growth was in no way slowing down. Here's a list of breweries that were near to announcing that they were open for business:

KENT FALLS BREWING COMPANY
33 Camps Road, Kent
www.kentfallsbrewing.com

NO WORRIES BREWING COMPANY
2520 State Street, Hamden
www.noworriesbeer.com

STEADY HABIT BREWING COMPANY
95 Bridge Road, Haddam
www.steadyhabitbrewing.com

TIDAL RIVER BREWING COMPANY
15 Cheryl Drive, Space 4K, Canton
www.tidalriverbrewing.com

VERACIOUS BREWING COMPANY
246 Main Street, Monroe
www.veraciousbrewing.com

CONNECTICUT BEER BARS

J. TIMOTHY'S TAVERNE

143 New Britain Avenue, Plainville
(860) 747-6813
www.jtimothys.com
Founded in 1985

While it doesn't have the largest number of taps in the state or even bill itself exclusively as a "craft beer bar," J. Timothy's Taverne plays an important role in Connecticut's beer scene. The sprawling restaurant and bar, which seats nearly five hundred people in total, is in a building that dates to 1789. It was known as Cook's Tavern after it was purchased by John Cook and was a popular stop on what was then known as the "College Highway," since it connected universities in Connecticut, Massachusetts and New Hampshire. Generations of Cooks expanded the building, as it stayed within the family for quite a long time.

In 1979, Tim Adams and Jim Welch purchased the building, which was still operating as a bar but had seen better days, Adams said. After a renovation, it opened as J. Timothy's (a mix of the owners' names). Before the concept of craft beer was emerging on the East Coast, J. Timothy's was offering quality imported beers from Ireland, England and Germany. "When Sam Adams came into town, we were one of the first, if not the first, to carry them," said Adams, who said that he hosted the Boston Beer

Company president, Jim Koch, when the founder of Sam Adams beer was selling his product personally. The restaurant carried what few Connecticut beers there were in the 1990s, like Elm City Brewing of New Haven and Hammer & Nail Brewing of Watertown.

When the Connecticut beer scene exploded around 2010, J. Timothy's was poised to highlight what the brewers were producing. The driving force behind the push for local beer is Nikki Vinci, the restaurant's "beer and social media coordinator." While serving as a general manager of a brewpub in Charlottesville, Virginia, Vinci was drawn more and more to the beer world. To say it's an obsession for her might be accurate. There are always plenty of Connecticut beers on tap, and her efforts led to dedicating one of the twenty-four taps to Relic Brewing, a small brewery in their hometown of Plainville that produces a rapid turnover of new beers. Another tap was dedicated to New England Brewing; when Vinci tweeted that its Fuzzy Baby Ducks IPA was on tap, it caused a line to form outside the restaurant at 11:00 a.m. "I think we were the first ones to do a beer 'tweet-up,'" Vinci said about an event from around 2011. "We decided to ask people on Twitter what should be on our beer list. Within two days, we had twenty-five people; they all came in, and we gave them samples of beer and got their feedback. That's what a lot of people don't get about social media. It's not just about sending messages out, but also getting information." You can follow Nikki on Twitter yourself (@jtimothys).

Its twelve-seat bar area always seems alive with vibrant conversation, some of it no doubt fueled by those twenty-four taps. All of the bar staff must take an exam about beer from the Ciccerone Certification Program, so you know you'll get educated recommendations for beer and food pairings. Near the bar is the wood-accented pub, and above it is the loft, where you can watch some of the flat-screen TVs that are tastefully arranged so as not to throw off the homey atmosphere. Much of the restaurant has an eighteenth-century feel, especially the smaller dining rooms. The decoration is spare, however, and you don't feel like you're eating in a museum. There's delicious food, of course, and J. Timothy's is specifically known for its "dirt wings," which are basically cooked, and re-cooked, wings that are succulent without resorting to a ton of gooey sauce.

Appendix II

Eli Cannon's Tap Room

695 Main Street, Middletown
(860) 347-3547
www.elicannons.com
Founded in 1994

For exposure to a variety of beer in an eclectic environment, there's a bar you can go to that started celebrating craft beer more than a decade before others in Connecticut would begin to catch on. It's stuffed floor to ceiling with bric-a-brac like an old gas pump, flags, a bicycle, black-and-white photographs of anonymous people, license plates and vintage beer memorabilia. It's situated in the north end of town in what was once a rather rough area. Now that part of town is marketed as NORA, or North of Rapallo Avenue, and it's home to a thriving cupcake bakery (partially owned by the Eli Cannon's co-owners), restaurants and more. Eli's is co-owned by Phil Ouellette and Suzanne Cannon, who were once married but remain business partners. The bar is named for the couple's son and was once a bit of a biker bar called Mothers. Now it's got a much more family-friendly feel, especially if your family drinks high-quality beer.

The man in charge of making sure the beer stands out from the growing competition is Rocco LaMonica, who started washing dishes at Eli's in 2007, only to work his way up to general manager. He's trained himself to keep up with the knowledgeable crowd, especially members of the bar's mug club, which has a ten-year waiting list. "When I first started here, it was an older crowd," LaMonica said. "The craft beer drinker was a Sierra Nevada drinker, which was their staple. They were the forty-and-up crowd. In the last three years, they are still there, but the even more passionate crowd is the young crowd. That's what I find is the most passionate."

Eli's has thirty-six tap lines, half of which tend to be flowing with Connecticut beer. He dedicated two lines to New England and Black Hog brewing companies, and once word goes out via Eli's social media presence, you might find it a tight squeeze in the narrow bar section. "Even in the last three years, the amount of breweries that have opened up in state has exploded, and now there are more people wanting beer from local breweries and requesting something obscure from Connecticut that's tough to get their hands on," LaMonica said. "Their passion drives me to find them." Being in Middlesex County is a disadvantage, he said, since some breweries do not have contracts to distribute there. That means working with breweries so

that they can bring their product directly to the bar sometimes. Luckily for drinkers at Eli's, Stubborn Beauty Brewing is only a few miles away and is often on tap.

Eli's is a fun, comfortable place to hang out. I had an event for my bachelor party in the back patio, which during the warmer months is a pleasant oasis of picnic tables and Adirondack chairs. It also offers paddles, known as "billy clubs," on which you can order five different samples of beer.

THE GINGER MAN

64 Greenwich Avenue, Greenwich
(203) 861-6400
Founded in 2002
99 Washington Street #2, South Norwalk
(203) 354-0163
Founded in 2007
www.gingermanct.com

For touches of elegance with your beer, there's the Ginger Man pair of restaurants, found in South Norwalk and Greenwich. They're part of a chain with restaurants in Texas and New York, but owner Christian Burns—whose restaurant group also owns the Cask Republic restaurants in New Haven and Stamford—tries to keep a Connecticut focus on the tap lines. They have the feel of being in an old-fashioned, intimate tavern, and the beer selection is strong, with more than twenty-three rotating draft beers in Greenwich and forty-nine in South Norwalk. You'll get a variety of styles, from German bock beers to imperial IPAs from Colorado, California and Connecticut. They keep seasonals rotating as well, along with beers served on nitrogen taps and regularly in casks.

"We're seeing Connecticut beers getting cult followings," said Burns. "I try to put my finger on the pulse of what local drinkers want. We try to promote the best beers that come out, whether it's from Two Roads [of Stratford] or New England [of Woodbridge]." Burns said that servers in both restaurants try to make the drinkers feel welcome and offer ways to "evolve their palates." Beer dinners go a long way to converting the casual beer drinker to one who is more devoted.

Appendix II

Prime 16

172 Temple Street, New Haven
(203) 782-1616
Founded in 2008
464 Boston Post Road, Orange
(203) 553-9616
Founded in 2013
www.prime16.com

Craft beer bars play a significant role in the world of Connecticut brewing, and oftentimes the determining factor behind a successful or unsuccessful bar is its manager. He or she is the conscience of a drinking establishment, the author of the story that is the tap list. Some have created dynamic narratives, featuring local breweries when no one would or maintaining an entertaining array of crowd- and geek-pleasing IPAs, limited-release winter warmers and even cask-conditioned curiosities.

The creative mind behind the twenty-beer tap list at Prime 16 in New Haven is Larry Townsend, a former art school student who's witnessed the evolution of craft beer in Connecticut at close range. By the mid-1990s, when the wave of New England–brewed beers was cresting, Townsend was manning the bar at Eli Cannon's Taproom in Middletown, his hometown. He'd order the beer, wine and liquor and anticipate the desires of the thirsty patrons. "This time is like that time period: a lot of growth, a lot of brands you didn't know are now around," he said during a midweek afternoon lull, when he could take a corner table in peace. "I think the ones that can keep up the quality are the ones that will survive. There are important lessons to learn from that time."

After more than ten years at Eli's, Townsend moved onto a new restaurant opening up in downtown New Haven, not far from Yale University and the theater district. Prime 16 was a partnership of restaurateurs who were looking to focus on burgers and beer, a seemingly surefire combination for a college town. At first, customers focused on the beer, a healthy selection of craft, imports and even some macrobrewery options. Over time, it became known also for its burger selections (including an amazing honey truffle burger that features applewood bacon) and consistent focus on American breweries. "We're not quite a bar, we're not quite a restaurant—we straddle the line of each," Townsend said.

The restaurant stands in the center of a pretty nice pub crawl: BruRm @ BAR, a brewpub, is a few blocks away; Cask Republic, an even bigger craft beer bar, is right around the corner; and Ordinary, a retro bar with some high-end beer choices, is nearby on the New Haven Green.

Prime 16 could be considered an upscale burger joint or a casual craft beer restaurant. Its dining room seats about sixty people at the square tables among reddish brown walls that almost resemble clay. The wooden, L-shaped, twelve-seater bar sits in a room that could hold another thirty souls, and it is dominated by a giant chalkboard menu that lists the beer it offers on tap, along with the styles and alcohol content. On a recent trip, there were three Connecticut beers, including a brown ale from not-even-open-yet Black Hog Brewing of Oxford. The rest were a mix of Belgian-style beers from Maine, a lager from Massachusetts, two ales from a Michigan brewery, California IPAs and a hard cider. "We try to offer new things constantly," Townsend said. "There will be people who are disappointed that their favorite isn't always on, but we like to introduce people to new beer."

While Townsend supports Connecticut beers, he does not do so blindly. The tap list always includes at least one beer from New England Brewing of Woodbridge, which Townsend sees as support for the strongest brewery in the state in terms of its offerings. He's also bullish on Two Roads Brewing of Stratford, the giant brewery (by Connecticut standards) that has carved out a sizable niche for itself in just a few years. "Two Roads is the exception to what's going on [in Connecticut beer]," he said. "That was well planned out from people who made great connections. But as far as [some other brewery owners] Connecticut, it's a part time job for them. Some can't do it 24/7. That's good and bad. Sometimes your part-time job suffers. I think the breweries trying to…do some crazy single-hop IPAs, I don't see that as a sustainable model. The skill set isn't there; it tastes like homebrew."

Prime 16 does what it can to lure you in and keep you there. Its "happy hour," from 4:00 p.m. to 7:00 p.m. during the workweek, features most beer at half price. There's also always a line that's a "nitro," meaning it shoots nitrogen through the beer, making it noticeably smoother in texture. It also offers tap takeovers, meaning it will give over a series of taps to just one brewery; the one for New England Brewing has been known to create standing room–only crowds. For a larger version of the restaurant in a suburban setting, you can go to Prime 16 in Orange, which is about eight miles southwest.

"I think we offer a pretty laidback, unpretentious experience," Townsend said. "I want people to enjoy themselves, be responsible, have a good time

and talk to the person next to them. It's not the place where people go to get sloppy drunk and not respect what they are drinking. Our clientele is a bit more sophisticated than that. It isn't a college bar."

MIKRO CRAFT BEER BAR

3000 Whitney Avenue, Hamden
(203) 553-7676
www.mikrobar.com
Founded in 2010

When Mike Farber was scouting for properties to turn into a craft beer bar, he kept his eye out for character. He knew that he wanted a space in Hamden, which is in central Connecticut, north of New Haven and home to Quinnipiac University. There was something about the small space at 3000 Whitney Avenue, and it wasn't the beer funnels hanging from the ceiling. It was how high the ceiling was that grabbed his attention, actually, and from a run-of-the-mill "college bar" in a far-from-exotic strip mall, he saw possibilities. Adding touches like an untreated maple bar, rough wooden beams over the bar and industrial-grade metal accents, Farber had the look he wanted. The proof of the place would come from the tiny kitchen and the eighteen taps.

This wasn't Farber's first foray into restaurant ownership and craft beer. While still a student studying culinary arts at Johnson & Wales in Rhode Island, the Connecticut native opened a deli in Stamford. He moved on to another venture in North Branford, where he and his wife opened Good to Go, a breakfast and lunch spot. When he and a small team opened Prime 16 in downtown New Haven, the world of craft beer officially melded into Farber's view of what a restaurant can be. At the time, Blue Point Brewing from Long Island was more popular than anything being made in Connecticut. That has all changed in the past few years, he says.

Farber sold his part of the business to expand into a venture that would put emphasis on creative food to go along with the beer. "Prime 16 was originally about craft beer and burgers," Farber said. "At Mikro, we try and make food that's as good as all the craft beer that's around here. I have to serve a food product that's as artisanal as the beer." This meant giving his chefs free rein, which translates into a rotating seasonal menu that emphasizes staples like burgers and grilled flatbread sandwiches, along with specials that feature

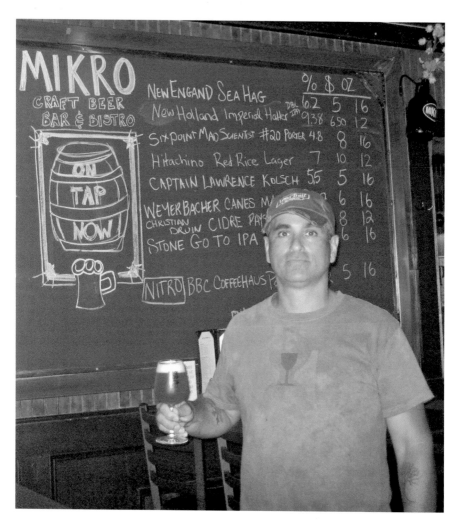

Mikro Beer Bar owner Mike Farber. *Photo by the author.*

local ingredients. Standouts include the "French Revolution," flatbread with Mornay sauce and duck bacon, steamed mussels with fries and pork belly bahn mi (smoked ham, pork pâté, house pickles, Sriracha mayo, sweet chili sauce, cilantro and pickled carrot on a crusty baguette).

As for beer, Mikro tries to make room for a diversity of styles, usually from American brewers, with at least three lines flowing with Connecticut beers. "Every week now we have someone from Connecticut knocking at our door," Farber said. "There have only been one or two that we said, 'We can't sell you beer here.' We say that it's 'just not there yet.'" Mikro sometimes hosts special

events with the brewers themselves. Farber says that the bar serves as an excellent podium from which to educate curious drinkers. "As long as you are at least up for a conversation, we're going to win you over," said Farber, who is also a partner in Ordinary—an upscale bar in New Haven—and owns Smoke Box BBQ in Hamden.

Constantly talking about beer, whether it's on vacation or at the numerous field trips Farber takes to brew fests in and outside the state, is an essential part of the business. Such schmoozing yields key relationships between the bar and the brewers, especially the local ones. "We're really excited about what's going on in Connecticut," he said, noting that New England Brewing Company seems to be setting the benchmark for the rest of the state. "I don't know where Connecticut [brewing] is going to go. We want [the breweries] all to be in it for the right reasons, not making something because someone else wanted you to make it."

A night of drinking at Mikro can be a blast. With room for only about fifty people, it can get really cozy really fast. The narrow communal table is a great way to have beer geek conversations with strangers, although the bar itself is probably the best spot for hunkering down.

CASK REPUBLIC

179 Crown Street, New Haven
(475) 238-8335
Founded in 2010
191 Summer Street, Stamford
(203) 348-2275
Founded in 2014
www.caskrepublic.com

These restaurants give off the aura of high-end clubs for folks with more than a little spending money and a taste for fine beer. Each Cask Republic offers more than fifty taps and eighty bottles and cans for consumption, as well as savory food that pairs well with everything from the richest Belgian tripel to the most pungent of California India pale ales. These beer bars promote Connecticut beers as well, primarily offering New England Brewing but also giving space to newcomers like Black Hog and Half Full Brewing Companies.

They're owned by restaurateur Christian Burns, who started out with ventures in Texas, where he hooked up with the Ginger Man chain. After stints

working as a chef after graduating from culinary school in 1998, Burns returned to working with the Ginger Man group and continues to own two of his own Ginger "Men"—in Greenwich and South Norwalk. "I wanted to create my own world, and New Haven Cask Republic was my first baby," Burns said. He transformed an Irish-themed college bar downtown and turned it into a wood-paneled, indirect-lit sanctuary with five narrow tables in the center and square tables that surround them. You get the feeling you are in a mansion library, and being connected by a hallway to the Omni New Haven Hotel at Yale means that if you overdo it a bit, you've got a swanky place to crash.

True to their names, the restaurants offer at least one beer on cask regularly, and their staff is trained to answer questions from, "What's the difference between a lager and an ale?" to, "What pairs best with a rye amber with notes of bubblegum and ash?"

Backstage EDL

85 Main Street, Torrington
(860) 489-8900
www.backstageeatdrinklive.com
Founded in 2011

In Connecticut's Litchfield County, there are no breweries, at least as of this book's publication. The best you'll get are bars that specialize in craft beer. In the town of Litchfield, there's @ the Corner and Bohemian Pizza. Down the road is Torrington, where you can hit more than a dozen small bars, but only one has true beer geek credibility. With forty taps and a commitment to showcasing Connecticut beer, Backstage is a worthwhile destination.

The building itself is part of its charm. A high-ceilinged former downtown Mertz department store, the space is next to the Warner Theatre, a 1930s movie house that's been artfully transformed into an ornate community theater that also attracts national music acts. A door connects the restaurant to the Warner's Nancy Marine Theater, used for smaller productions. The staff is well trained in the art of quick turnover; just before a show, you'll see some acrobatics just to get the customers out of their booths and into their seats.

A thoughtful diversity of beer is essential to the Backstage's success. The business was actually built from the ashes of a short-lived branch of Cambridge House Brewpub, which remains in Granby. That venture went bust after only

a few years; luckily for Backstage, that came after some renovation. Instead of a brewpub, the 215-seat restaurant got the look of a music venue—including paintings of rock stars and occasional bands—with splashes of sports bar and casual dining spot all in one. One of the men responsible for the restaurant's success is the man responsible for ordering the beer: Chris Verrilli. The general manager (with a background in bartending and cabinetmaking) said that he tries to give his customers a broad selection, and thirty-six of the forty taps rotate quite regularly. Many of those taps often flow with local flavor. "We have a huge commitment to Connecticut beers," Verrilli said. "Connecticut has grown dramatically in their selection and improved dramatically in their taste."

If you were to belly up with Verrilli at the zinc and mahogany bar, you'd no doubt be taken in by a seriously engaging guy. The boyish fortysomething with a cocky grin has been working in the food industry since he was fifteen and bartending at eighteen in Westport, Connecticut. "I learned from an old-school bartender," he said. "He always brought the newspaper for the customer and spread it out for them. Larry knew the fundamentals of how to interact with people. You keep it personal but not too personal. It's all about hospitality." Verrilli organizes almost weekly "tap takeovers" at Backstage, offering as many as eighteen beers to a single brewery on a Thursday night. The bar is also known for its "cask wars," which are friendly competitions between local breweries that bring casked versions of their beers and see who gets the most in-house votes for their beer, as well as the most social media exposure.

Personally, I've enjoyed turning forty at the bar with a fun private party, and I am often found nursing a stout in the corner, reading an issue of the *New Yorker*. What's great is that you're always presented with new options; nothing stays on a line for more than two weeks. As Verrilli puts it, "Keep 'em fresh, keep 'em cold and keep 'em moving."

Barley Vine

182 Main Street, Bristol
(860) 589-0239
www.barleyvinect.com
Founded in 2012

Barley Vine is the product of a couple's vision to give their disparaged city some vibrancy. The gastropub, located in downtown Bristol, started as a pitch

from Victor and Terry Lugo to a development firm interested in providing resources to help rebuild a city that hadn't celebrated many commercial triumphs since the 1950s. In 2010, New York–based Renaissance Downtowns became the city's choice for developer and approached the businesspeople of Bristol to offer their plans for new businesses.

The Lugos set out their vision: a craft beer and fine wine pub with an emphasis on craft—from the art on the walls to the food on the tables. They earned a chance to set up shop with Renaissance Downtowns' blessing and opened in October 2012 after refurbishing the first floor of a Victorian-era building that used to be a bakery. With its high, pressed-tin ceilings and red, exposed-brick walls, it's got the raw look of a hip city hangout. They expanded into the building next door for the dining area, which used to be an art gallery, and now have 2,400 feet of restaurant space, not counting the kitchen and back rooms. Including the twenty leather stools around the bar, the restaurant seats about 115 people.

The Lugos keep their fourteen taps rotating with a variety of beer styles. On a recent trip, I noticed several lagers, IPAs, a Belgian tripel, a pale ale, a bock, a red ale and a stout. Bristol is home to Firefly Hollow Brewing, and Barley Vine regularly features its beers. A U.S. Army veteran, Victor Lugo compared himself to a colonel who relies on the expertise of his staff to stay current with the best beers on the market. Indeed, three of his bartenders are Cicerone-certified beer servers. "I tell my staff, 'Don't tell me you like it. Tell me that [the customers] will like it,'" Lugo said.

Victor Lugo, a Bronx native who is of Puerto Rican ancestry, said he wants Barley Vine to represent the ethnic diversity of Bristol, and that extends to the food. With an executive chef trained in Italian cuisine, Barley Vine allows him to let loose with the broad category of "American pub food." There's a focus on natural ingredients, but not a lot of over-the-top spices. Lugo said it's a reflection of the "slow food" movement. The menu changes seasonally; some standout offerings include the porter chili with cornbread, Connecticut-based Sepe Farm lamb skewers over curried rice and house-made candied bacon.

Barley Vine hosts quarterly beer dinners, having done so with Samuel Adams beers, Firefly Hollow and Long Trail Brewing Company of Vermont. It also showcases the work of local visual artists on its walls and features live music.

Lugo holds out hope that Renaissance Downtowns will get the investors it needs and that a planned mixed-use development nearby comes to fruition. Candidly, Lugo said that he fears for his business if Bristol does not rise to the image that he has in his mind's eye.

Appendix II

The Corner Tavern

178 North Main Street, Naugatuck
(203) 279-3640
www.cornertavernct.com
Founded in 2013

When it was the Old Corner, this 1911 building and well-shined bar attracted loyal patrons who drank beer, especially during raucous St. Patrick's Day celebrations. When it changed management in 2013, co-owner Ryan Whipple left much of the original structure intact. He did, however, make a tremendous change to what flowed through its taps, introducing diverse, high-quality and often local beer.

The Corner Tavern, as it was rechristened, is a large, simple box of a room that faces a quiet street in Naugatuck, a town that once thrived as a former mill town. Like Naugatuck, the Corner Tavern has a lot of architectural charm, from its distinctive tin-ceiling painted bright red to its classically rotund urinals not to be missed by man or woman. There's a corner for live music and sometimes competitive karaoke, and you can get a hearty burger or other American fare.

Ah, but the beer. In bright, glowing marker on a black sign, the tap list announces the choices of twenty-five beers on twenty-seven taps (two are always held for ciders). Whipple is conscious of making sure there's a variety, and although they don't have the largest tap selection in the state, its often one of the most well planned. Being that the bar is close to Oxford and Woodbridge, the Corner Tavern often features offerings from Black Hog Brewing and New England Brewing. I had some limited-edition Palate Mallet from Back East Brewing and have enjoyed beers from California and Brooklyn as well.

Whipple and co-owner Tara Mitro try to use their tap list to introduce people to new beer, but they don't treat you like a philistine if you order Coors Light (which they carry, along with Budweiser, on draft). "I've been to craft bars with ten double IPAs," he said, referring to the usually bitter and sometimes off-putting beer style. "Everything's over 8 percent. I try to have a little bit of many styles: IPAs, pale ales, porters, stouts, Belgians." The Corner Tavern is definitely a laidback bar, whether you want to watch the game in silence or pontificate on the quality of hop-malt balance with gusto.

There are other bars and restaurants in the state that feature beer prominently. Following is a brief list:

@ THE CORNER RESTAURANT & PUB
3 West Street, Litchfield
(860) 567-8882

COALHOUSE PIZZA
85 High Ridge Road, Stamford
(203) 977-7700
www.coalhousepizza.com

DEW DROP INN
25 North Avenue, Derby
(203) 735-7757

EAST SIDE RESTAURANT
131 Dwight Street, New Britain
(860) 223-1188
www.eastsiderestaurant.com

THE ENGINE ROOM
14 Holmes Street, Mystic
(860) 415-8117
www.engineroomct.com

THE HALF DOOR
270 Sisson Avenue, Hartford
(860) 232-7827
www.thehalfdoorhfd.com

HOP HAUS
28 West Main Street, Plantsville
(860) 276-9326
www.hophauscraftbeer.com

McLADDEN'S IRISH PUBLIC HOUSE
Locations in Simsbury and West
 Hartford
www.mcladdens.com

PLAN B BURGER BAR
Locations in Glastonbury, Milford,
 Simsbury, Stamford and West
 Hartford
www.planbburger.com

RED STONE PUB
10 Jim Gallagher Way (Mall Way),
 Simsbury
(860) 217-1744
www.redstonepubs.com

WESTBROOK LOBSTER
Locations in Clinton and Wallingford
www.westbrooklobster.com

WORLD OF BEER
Locations in Stamford and West
 Hartford
www.worldofbeer.com

BIBLIOGRAPHY

Anderson, Will. *Beer, New England: An Affectionate Look at Our Six States' Past and Present Brews and Breweries.* Portland, ME: W. Anderson & Sons Pub., 1988.

Baron, Stanley, and James Harvey Young. *Brewed in America: A History of Beer and Ale in the United States.* Boston: Little, Brown, 1962.

Battista, Carolyn. "New Haven, a City of Beer Making (Until Prohibition)." *New York Times,* December 13, 1998.

Beecher, Lyman. "Six Sermons on Intemperance." University of Virginia. http://utc.iath.virginia.edu/sentimnt/sneslbat.html.

Brooks, Charles L. "Connecticut Goes Dry: The Experience of the Temperance and Prohibition Movements in Connecticut, 1850–1933." Master's thesis, Central Connecticut State University, 2006.

Caplan, Colin M. "Fermenting Evolution." *Daily Nutmeg,* February 26, 2014. http://dailynutmeg.com/2014/02/26/new-haven-beer-history-fermenting-evolution.

Crouch, Andy. *The Good Beer Guide to New England.* Lebanon, NH: University Press of New England, 2006.

Kish, Jules. *Beer Cans of Connecticut Breweries, 1935–2013.* Milford, CT: self-published, 2014.

Malley, Richard C., and Michelle E. Parish. "Beer and the Brewing of Beer in Connecticut." *Connecticut Historical Society Bulletin* 56, nos. 3–4 (1991).

Maynard, Preston, and Marjorie B. Noves. *Carriages and Clocks, Corsets and Locks: The Rise and Fall of an Industrial City—New Haven, Connecticut.* Hanover, NH: University of New England, 2004.

BIBLIOGRAPHY

McKinney, Jas. P., publisher. "The Industries of New Haven." The [New Haven] Chamber of Commerce, 1889.

Messina, Mike. "Something's Brewing." *Your Public Media*, April 29, 2011. http://wnpr.org/post/something-s-brewing.

Niven, John. *Connecticut Hero, Israel Putnam*. Hartford: American Revolution Bicentennial Commission of Connecticut, 1977.

North, Catherine Melinda. *The History of Berlin, Connecticut*. New Haven, CT: Tuttle, Morehouse & Taylor Company, 1915.

Ofgang, Erik. "Kent Falls, Stony Creek and Other CT Breweries Set to Open in 2015." *Connecticut Mag*, December 19, 2014. www.connecticutmag.com.

"Records of the Colony and Plantation of New Haven, from 1638–1649." Available at the New Haven Historical Society.

Roth, David M. *Connecticut: A Bicentennial History*. New York: W.W. Norton & Company Inc., 1979.

Thornton, Steve. "Union Brew." Shoe Leather History Project, June 17, 2013. http://shoeleatherhistoryproject.com/2013/06/17/union-brew.

Van Wieren, Dale P., and Donald Bull. *American Breweries II*. West Point, PA: Eastern Coast Brewiana Association, 1995.

Waldo, George C., ed. *History of Bridgeport and Vicinity*. New York: S.J. Clarke, 1917.

Archival material, including older volumes of the *Bridgeport Post, Hartford Courant* and *New Haven Register*, consulted at Bridgeport Public Library, Bridgeport; Connecticut Public Library, Hartford; New Haven Historical Society, New Haven; and *New Haven Register*, New Haven.

INDEX

ABOUT THE AUTHOR

Will Siss has been writing the "Beer Snob" column for the *Waterbury* (CT) *Republican-American* since 2005. Will earned a BA in English from Gettysburg College and an MS from the Columbia School of Journalism. When he is not writing about beer, he is leading beer-tasting presentations, writing humor pieces, playing in a band and teaching. Since starting his "Beer Snob" column, he has appeared on *Better Connecticut* (WFSB, Channel 3) with host Scot Haney, National Public Radio's *The Faith Middleton Show* and *The Colin McEnroe Show* and WATR 1320-AM's *Tom Chute and You*. To learn more, visit beersnobwrites.com.

Photo by Stacey Blanchard.